GEOMETRIC FLOWERS

Coloring Book

by Mary Layton

Geometric Flowers Coloring Book

Copyright © 2019 by Mary Layton

Cover by Mary Layton

All rights reserved. No part of this book may be reproduced in any form by any electronic or mechanical means including photocopying, recording, or information storage and retrieval without permission in writing from the author.

Web site: www.marylayton.net

Patreon: www.patreon.com/MaryHerself

2 each of 25 images

Try out different color combinations or tear and share!

For best results color with colored pencils or markers (sturdy, thick backing board recommended for use with markers to prevent bleed-through).

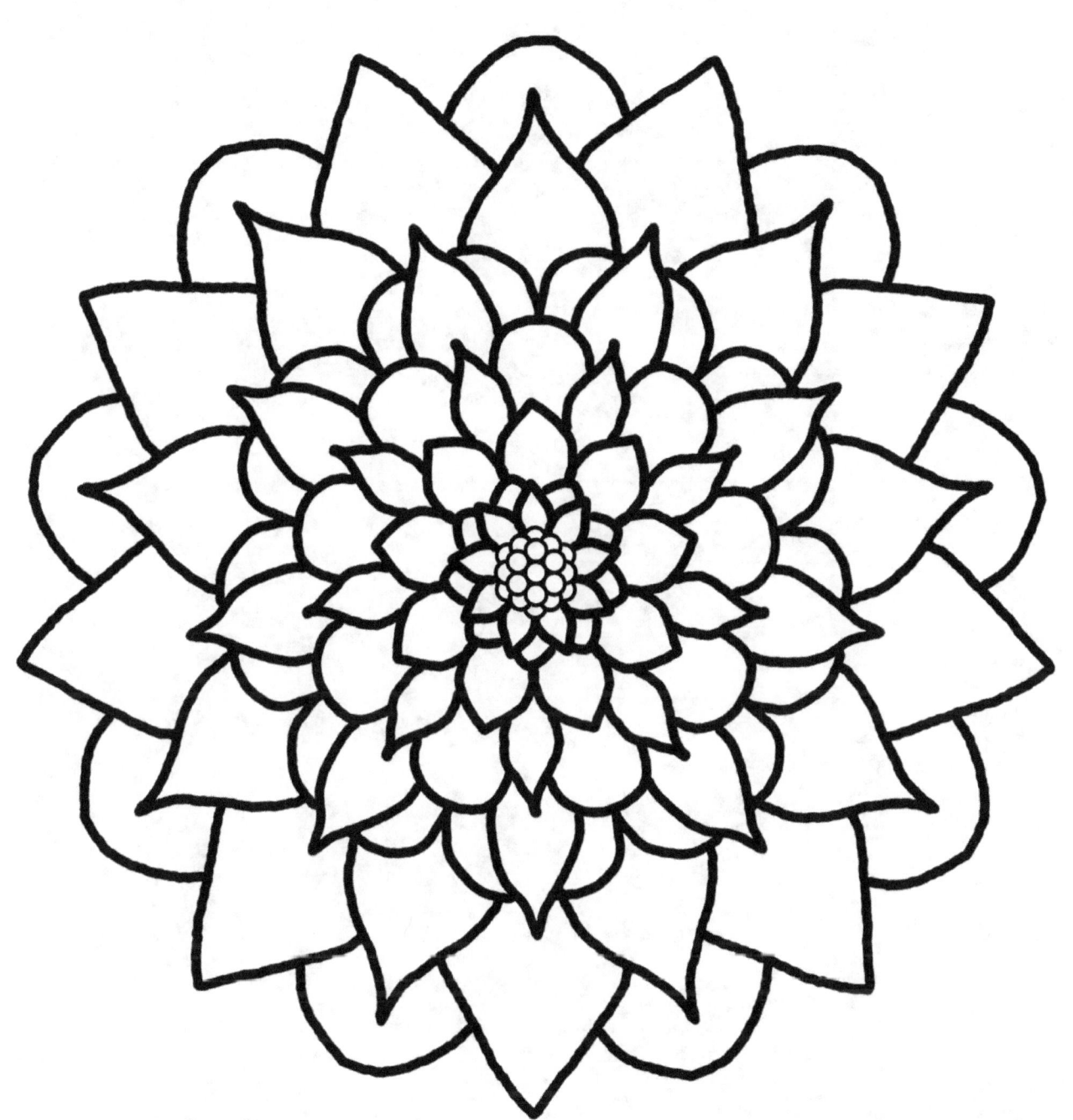

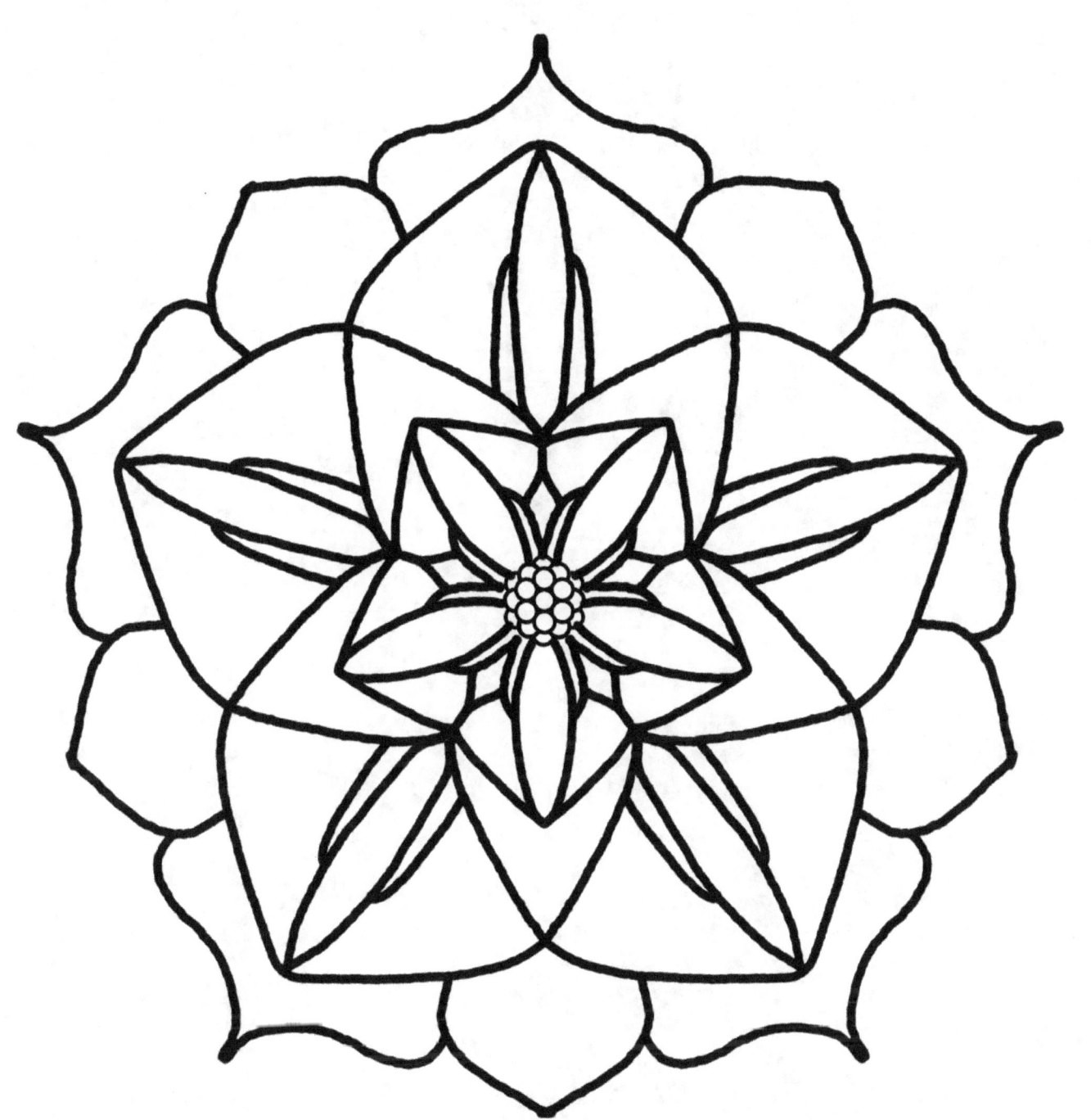

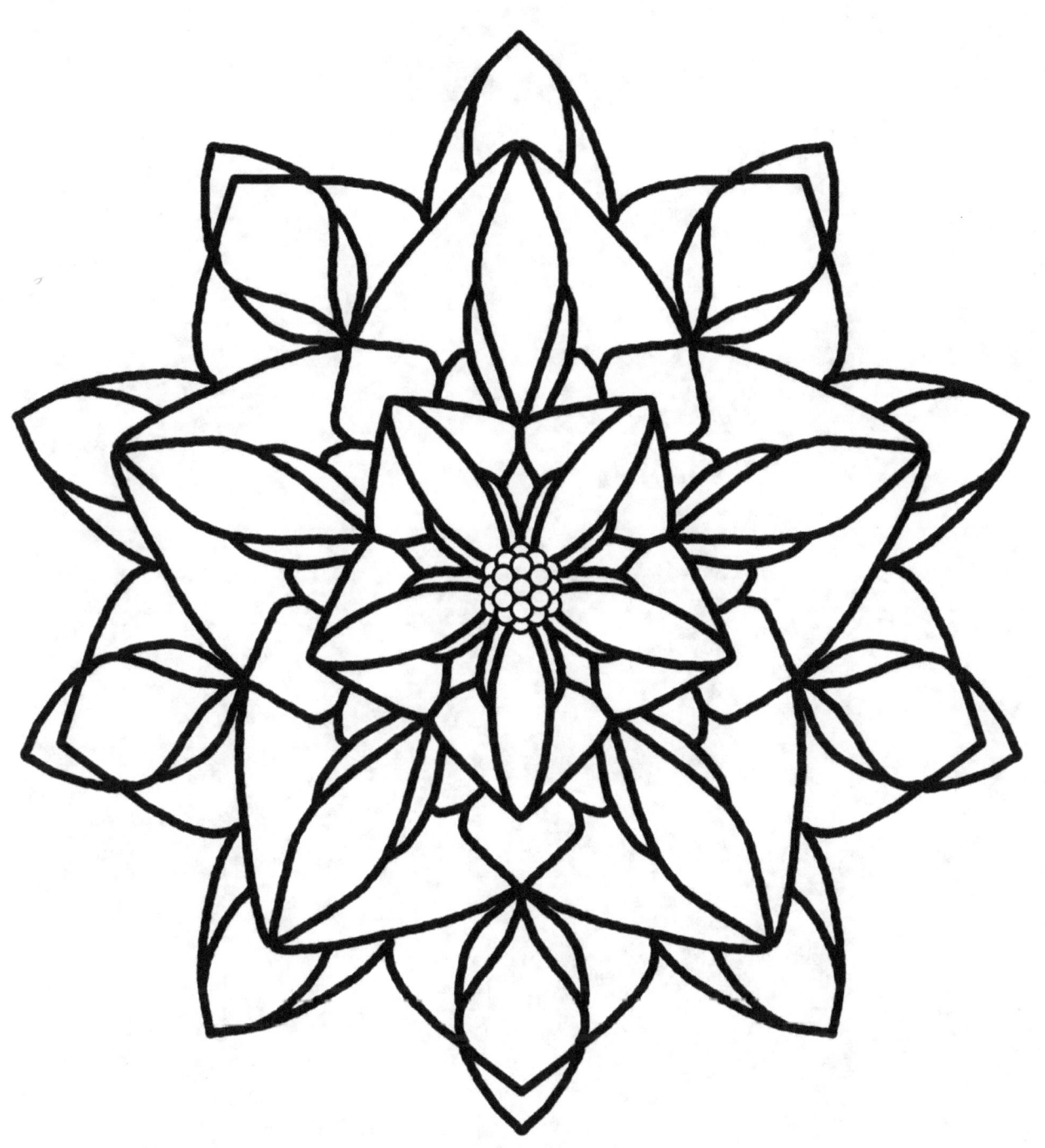

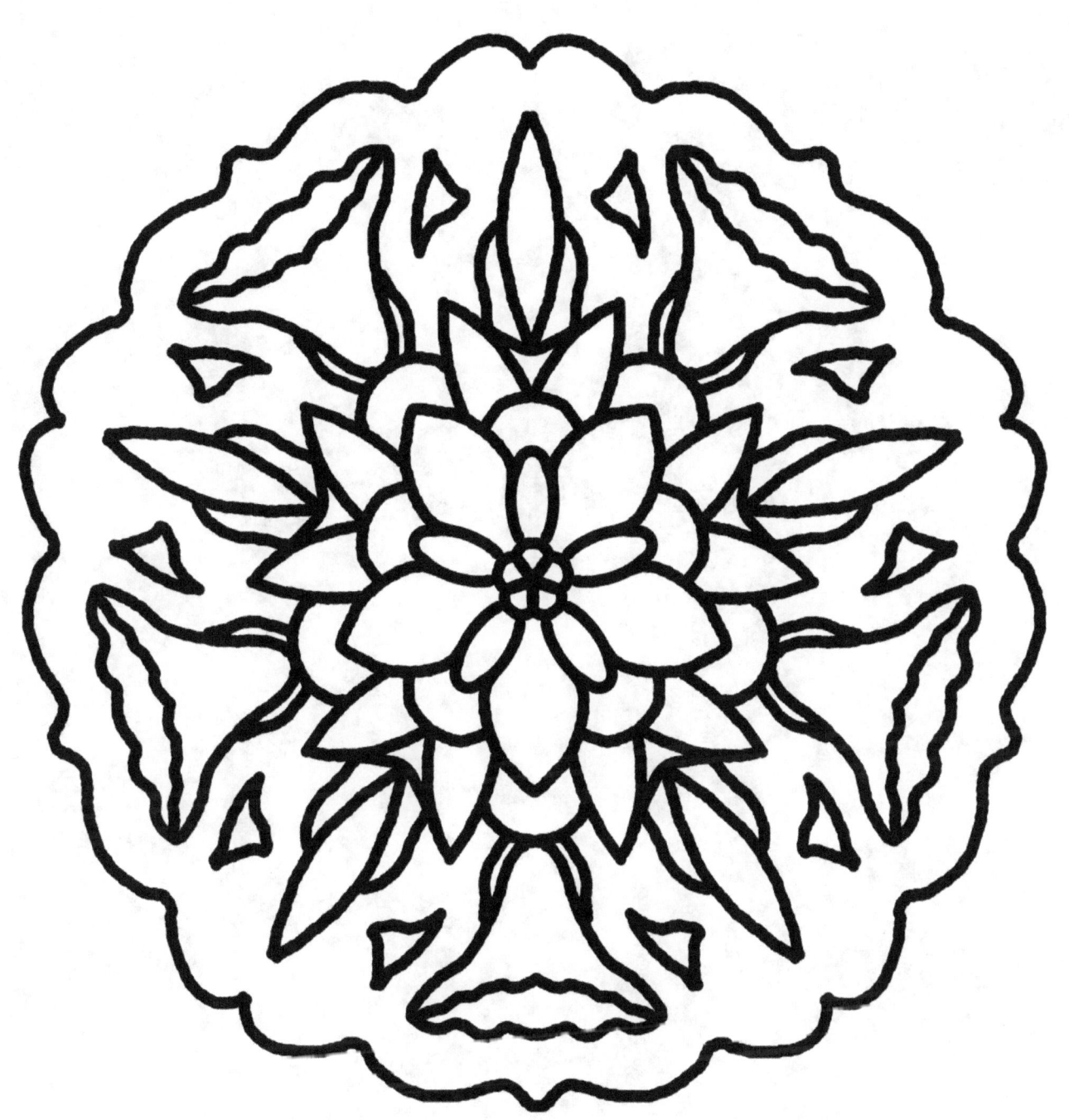

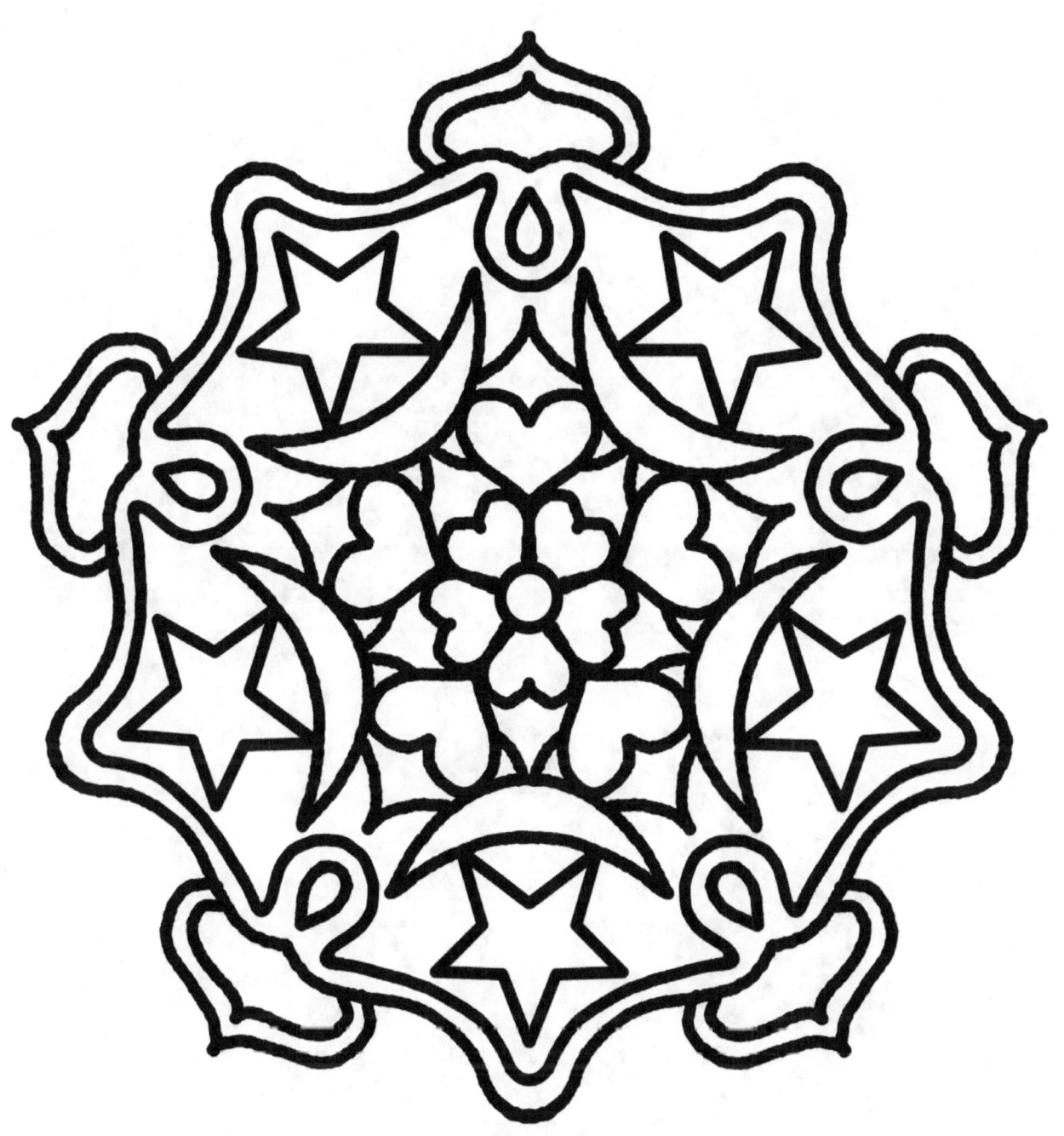

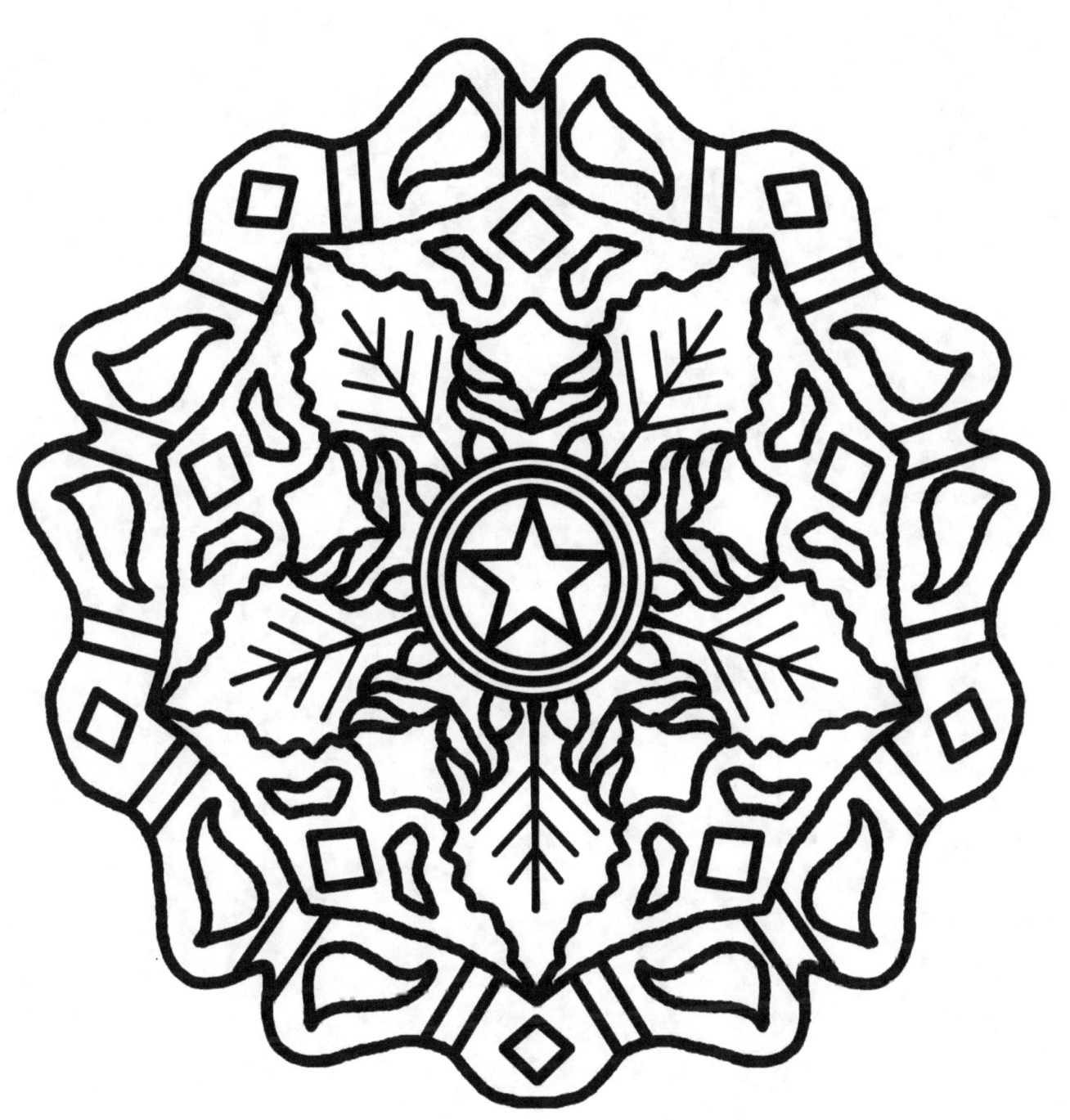

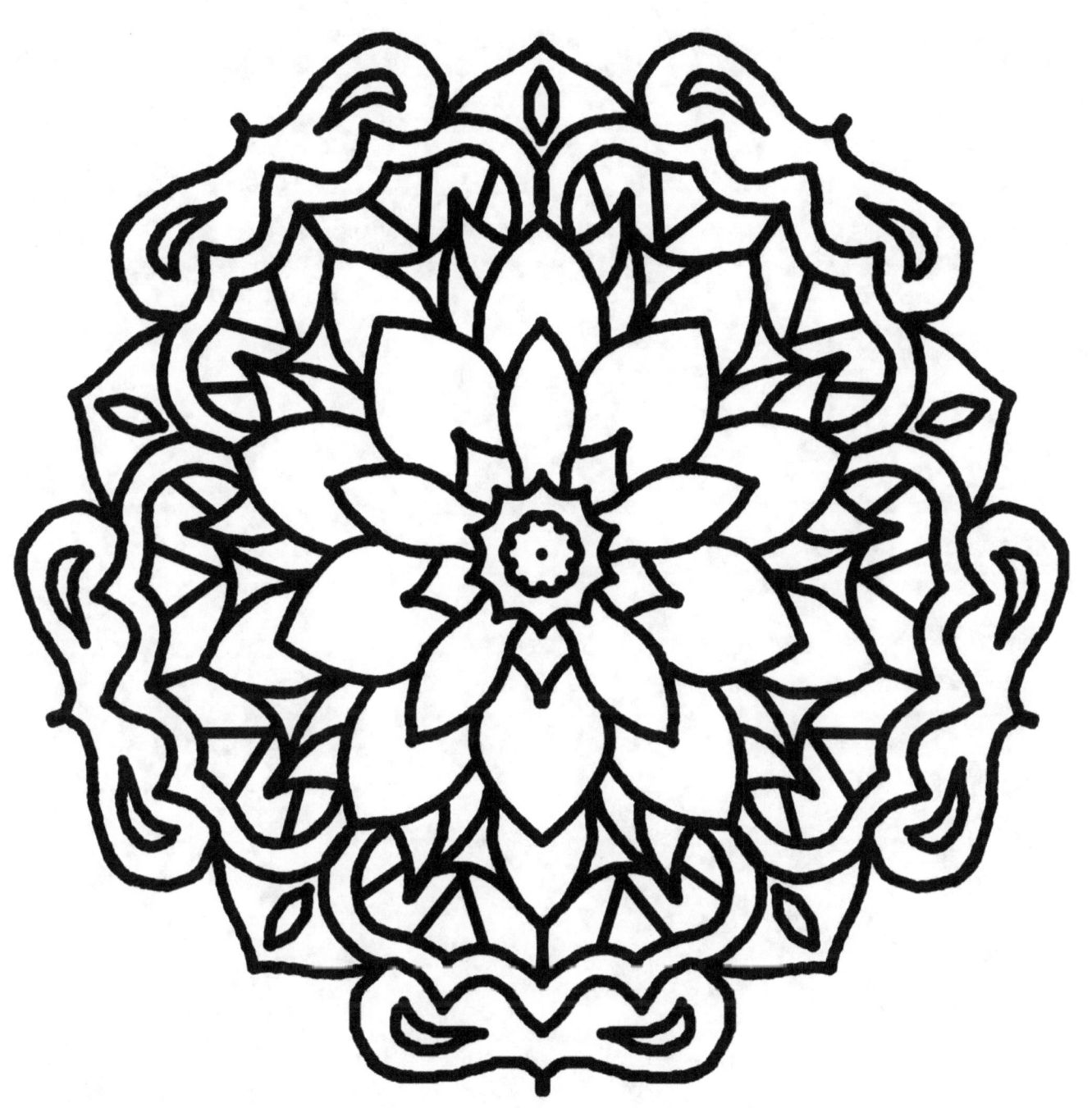

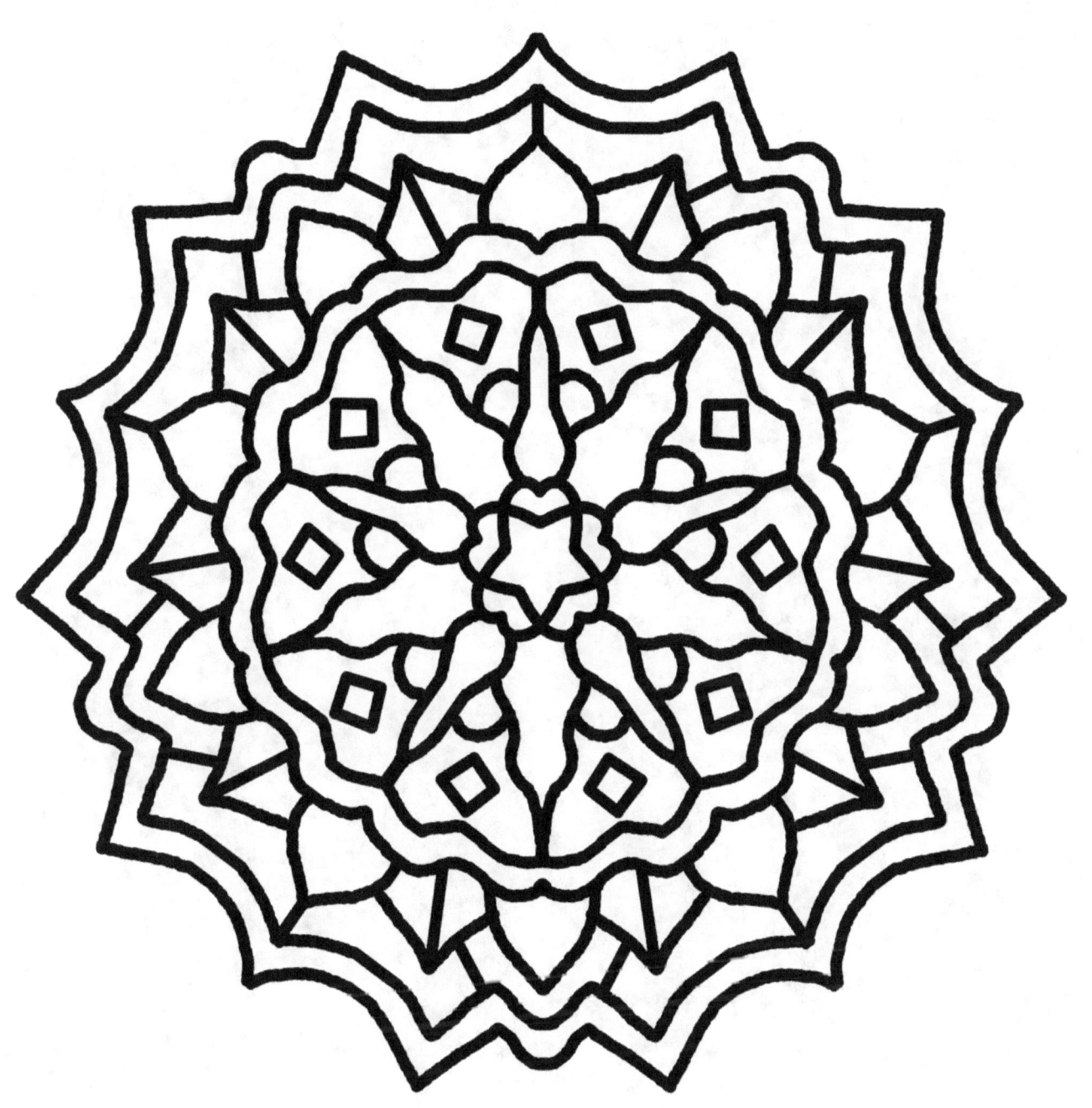

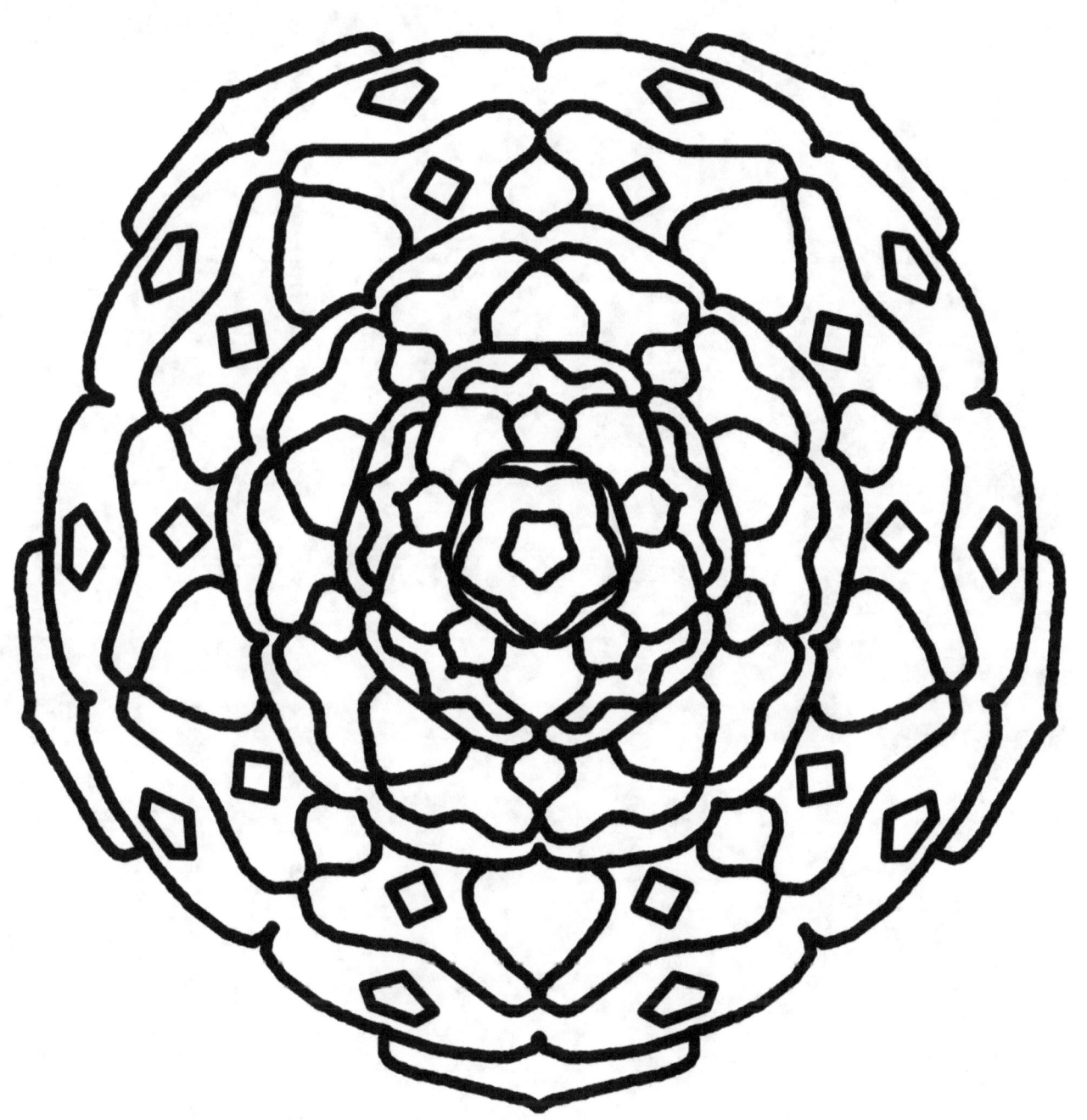

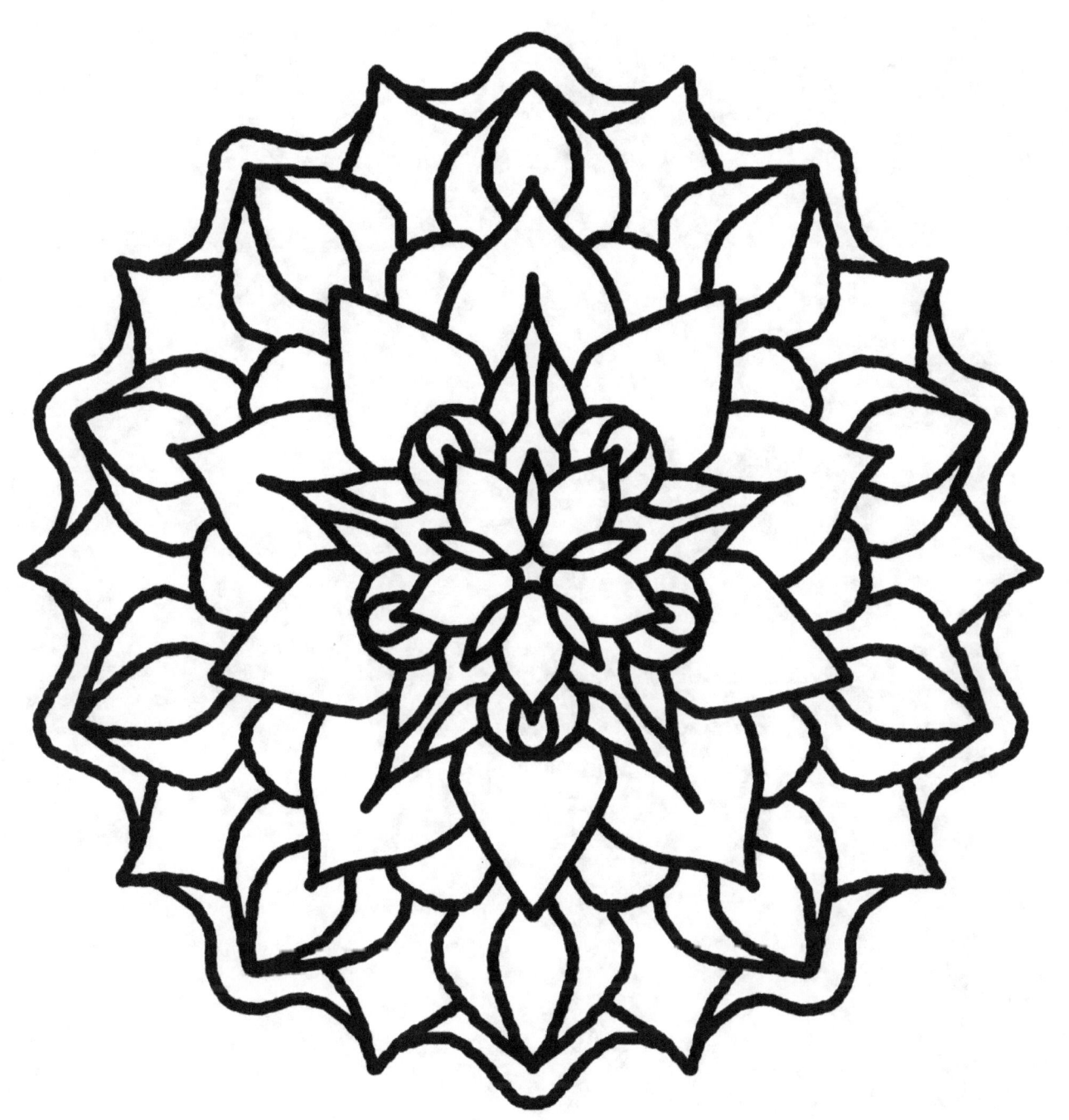

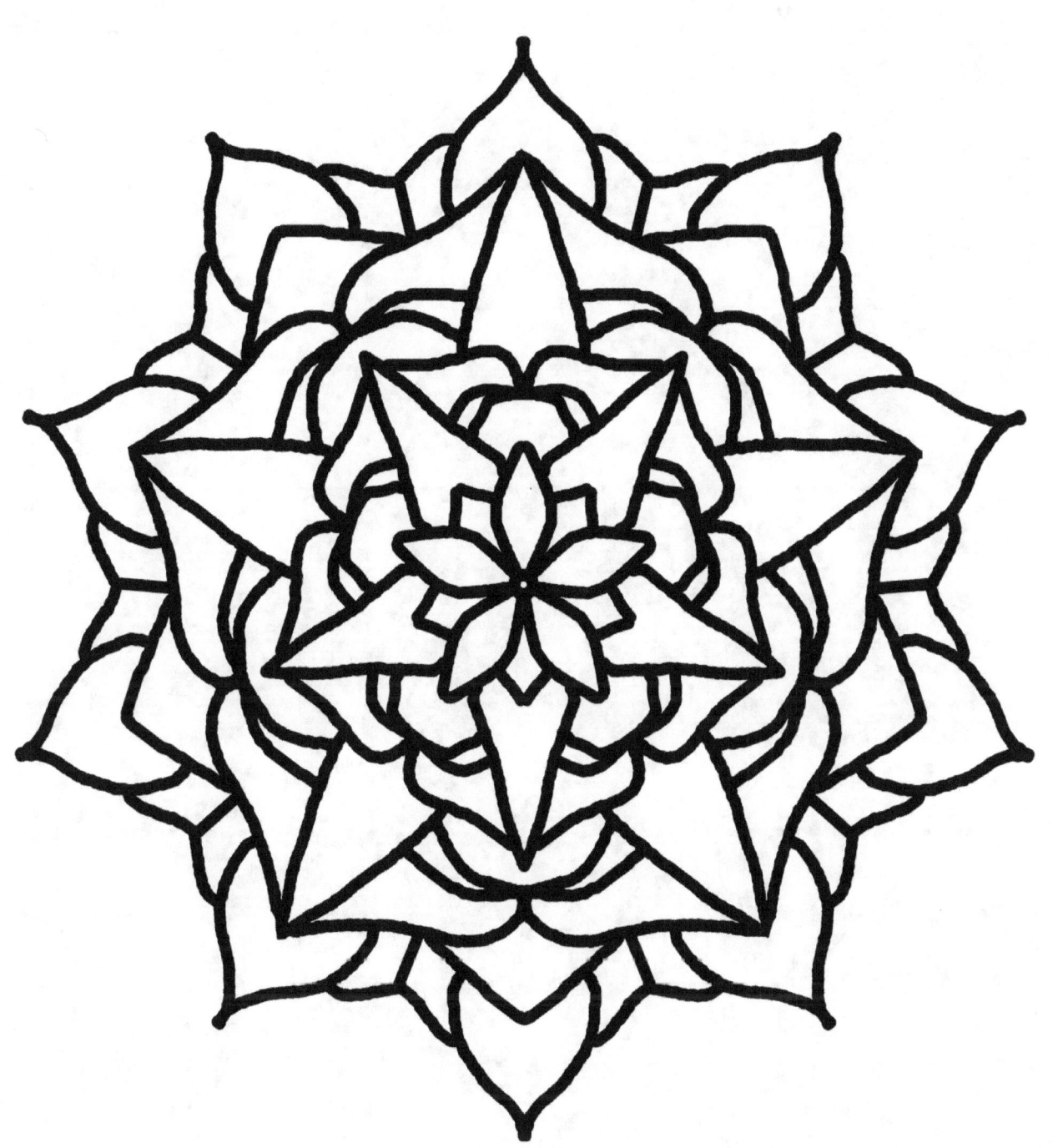

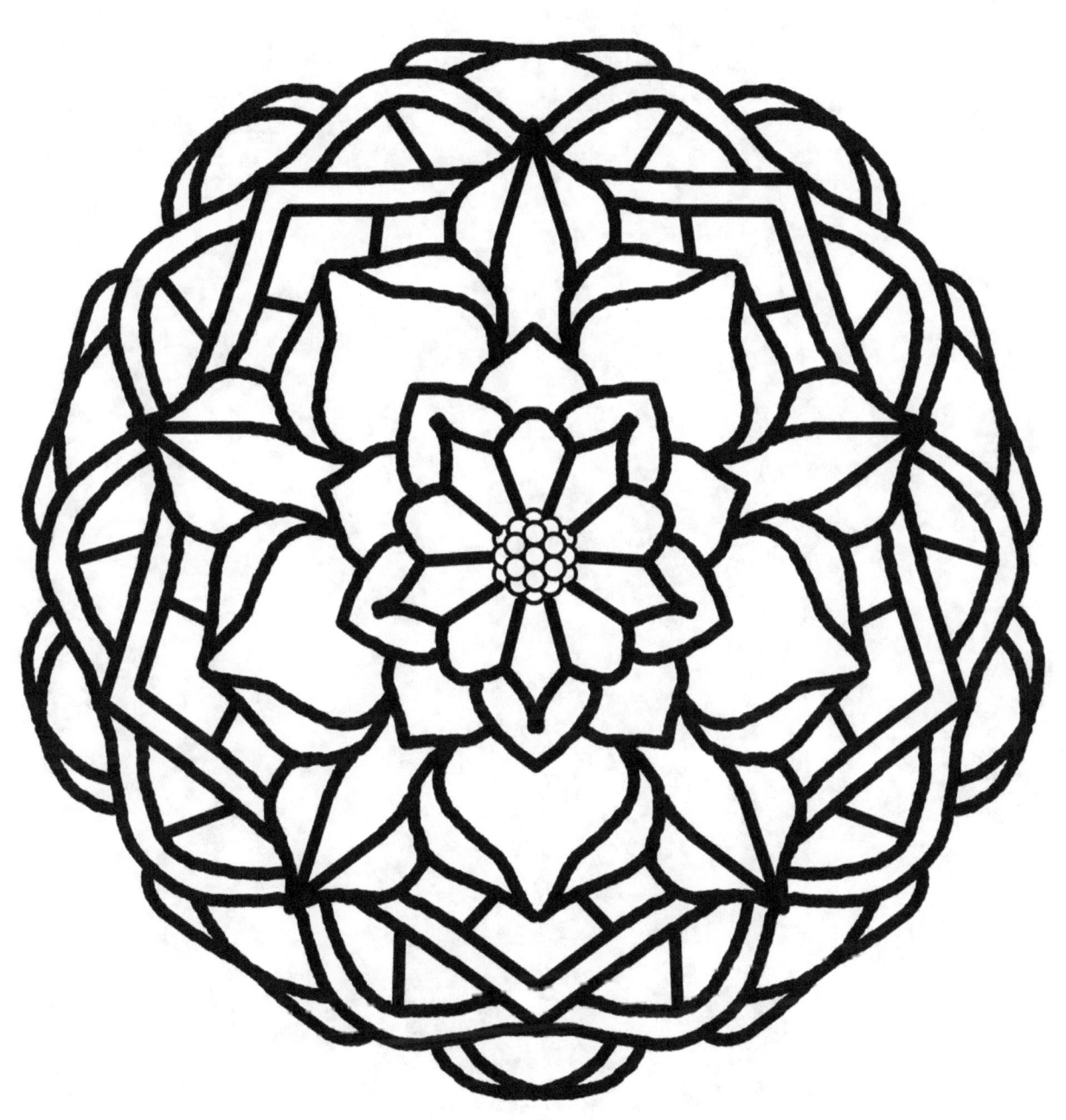

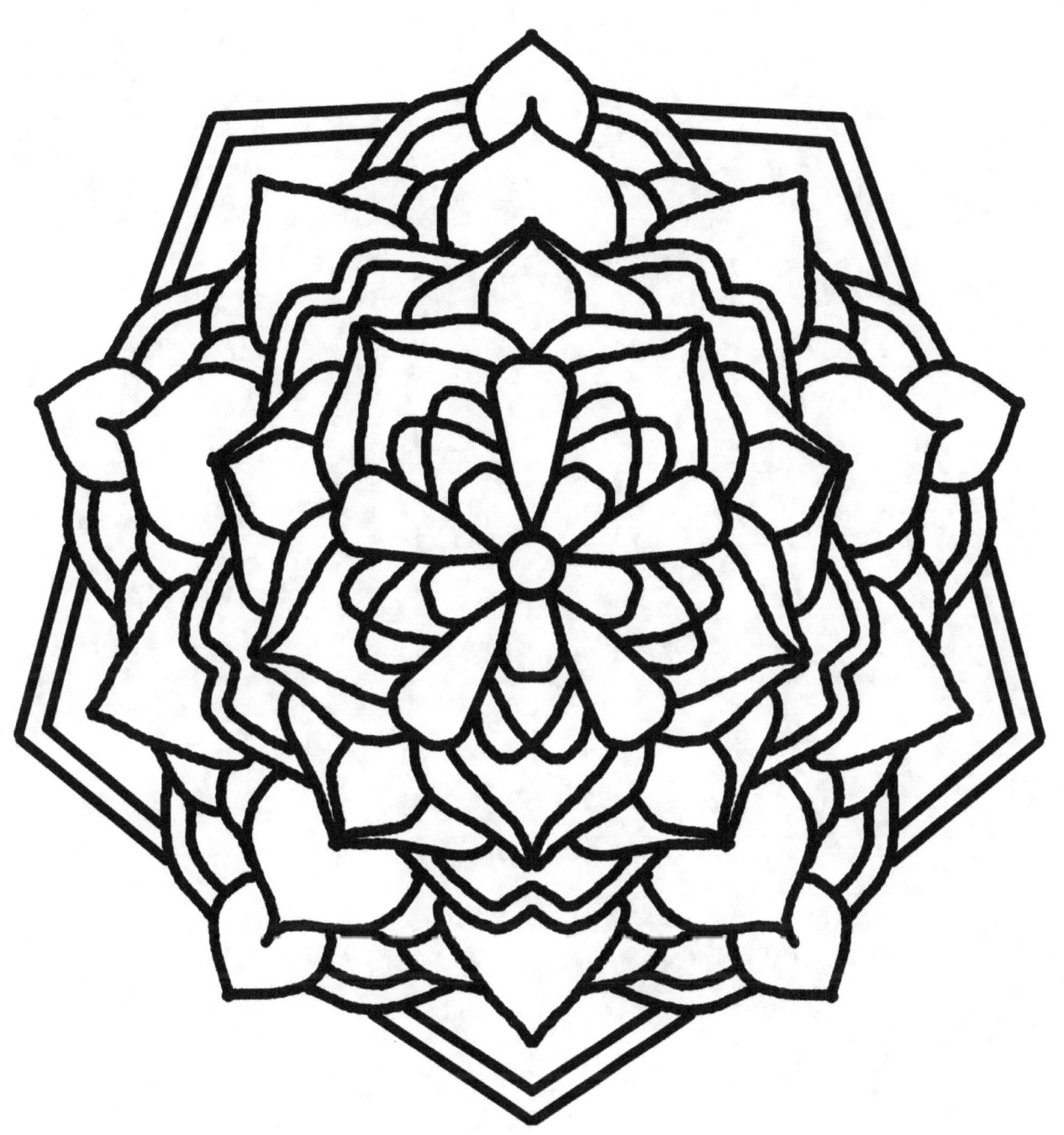

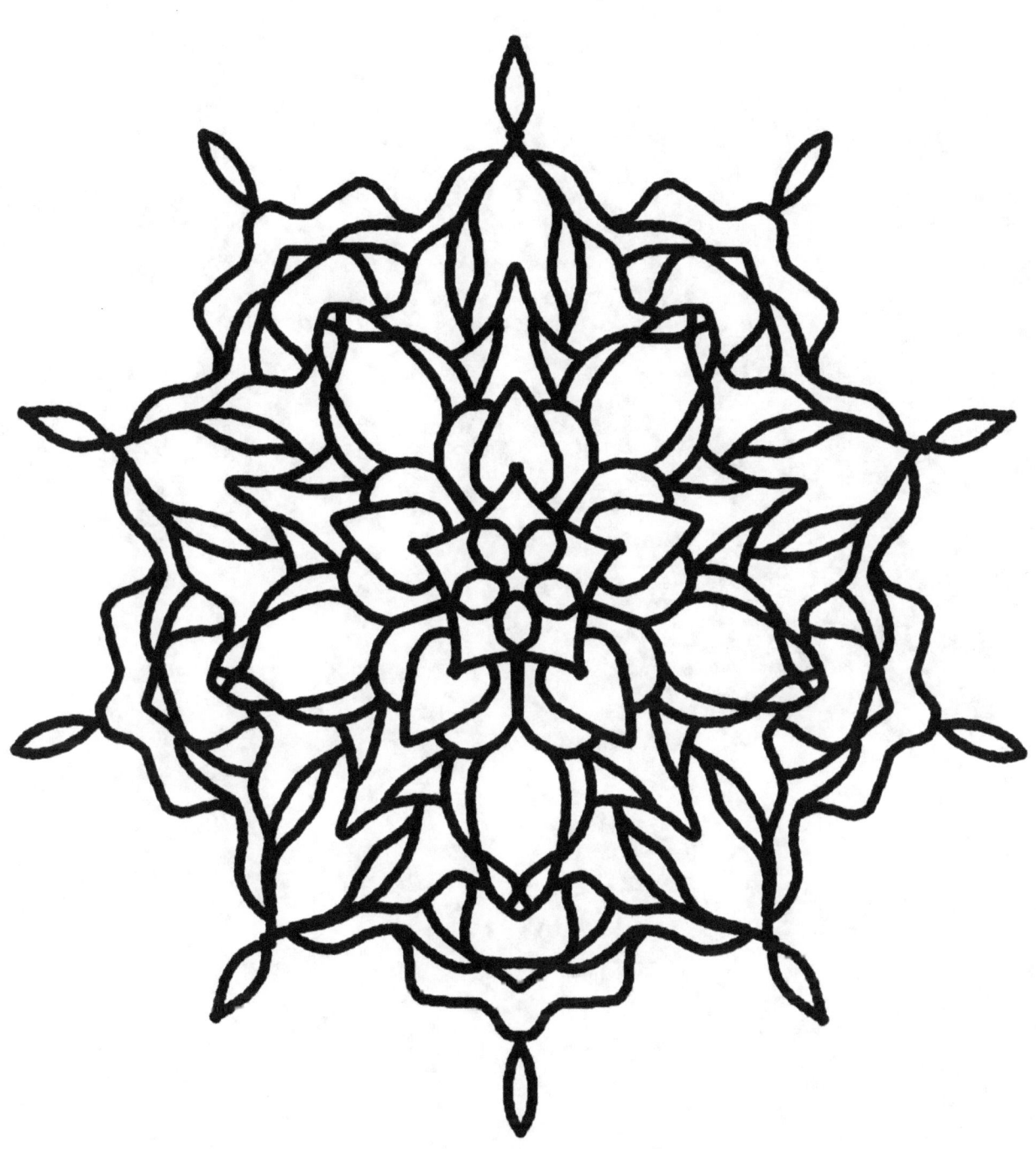

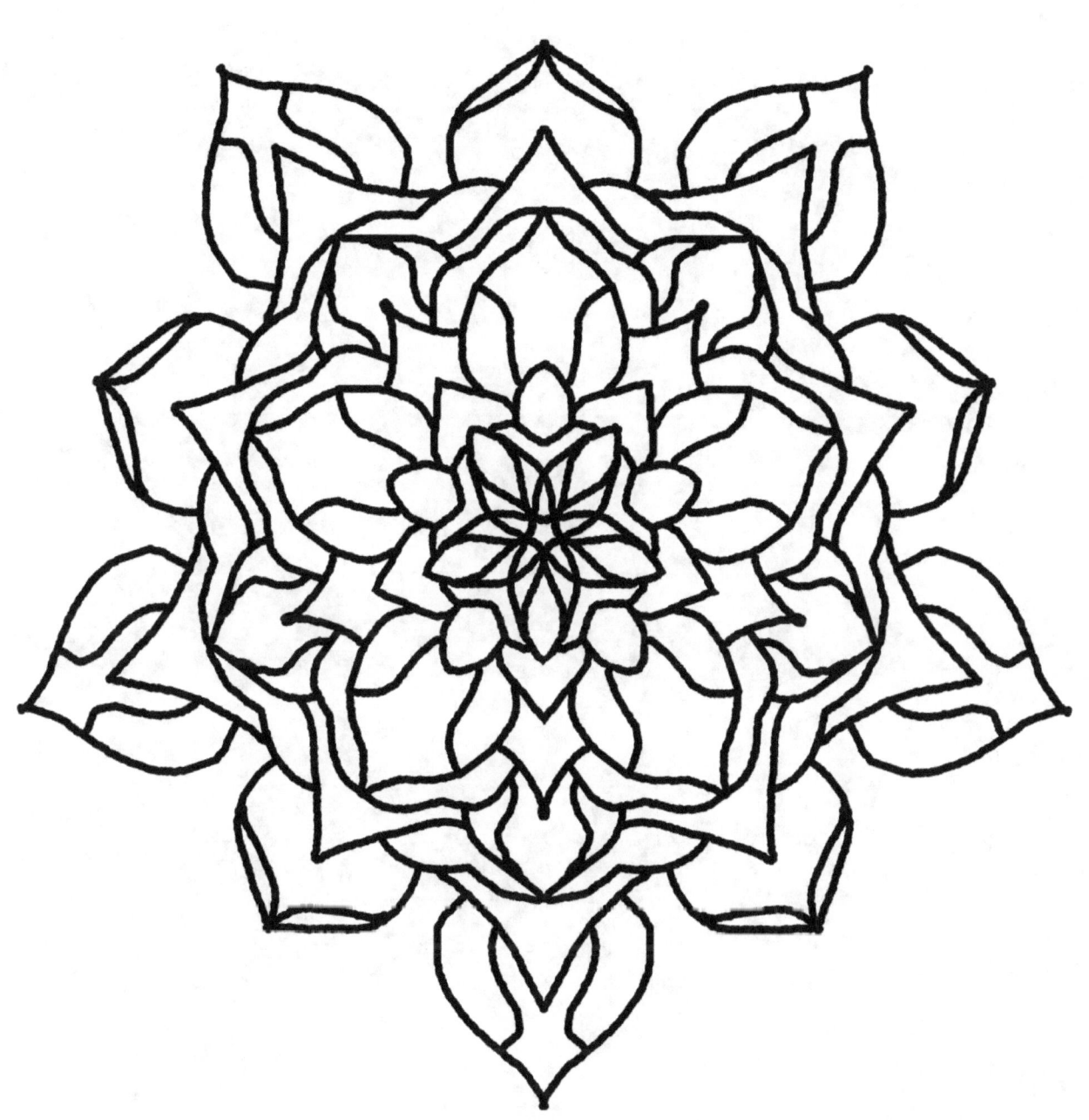

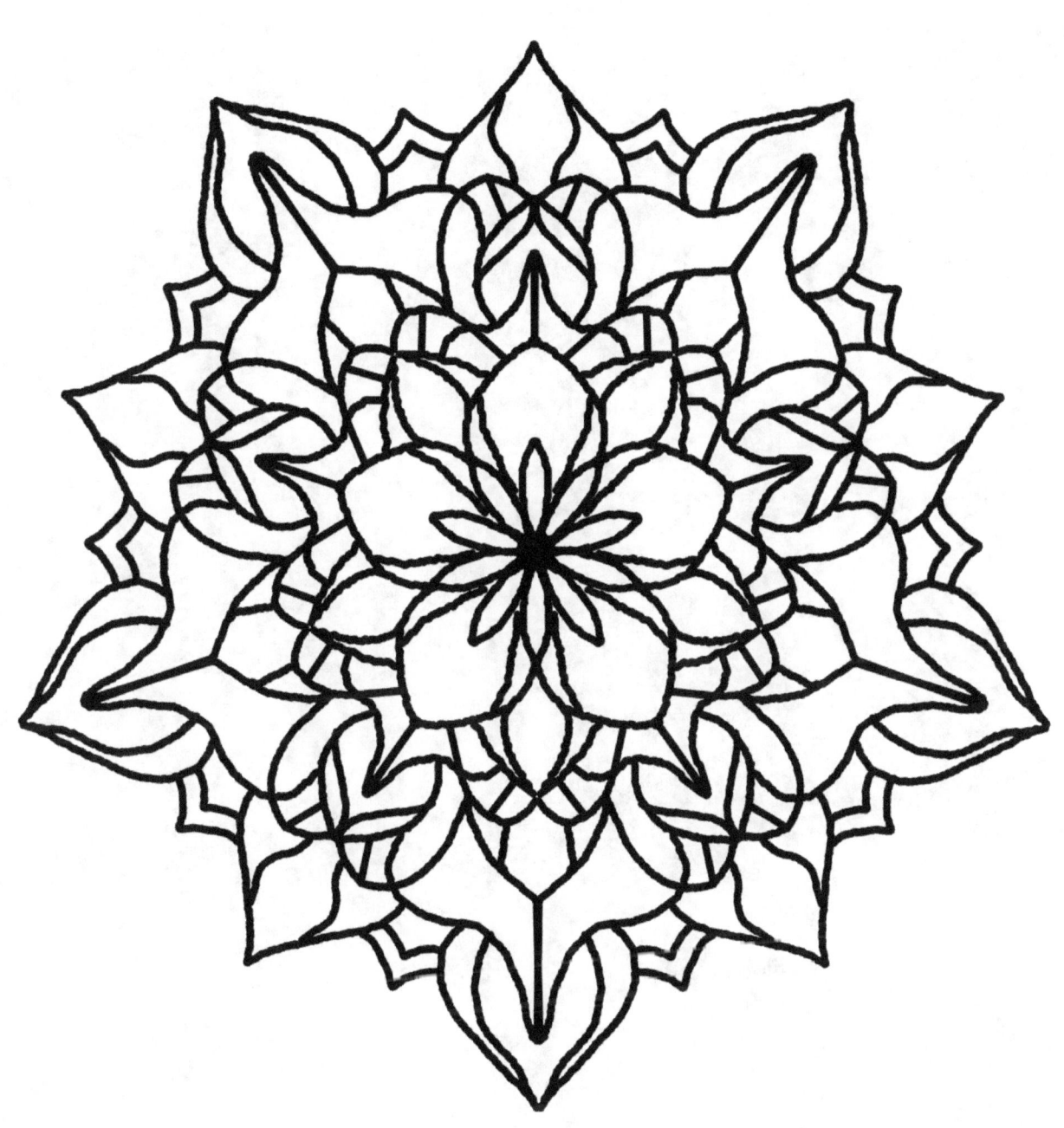

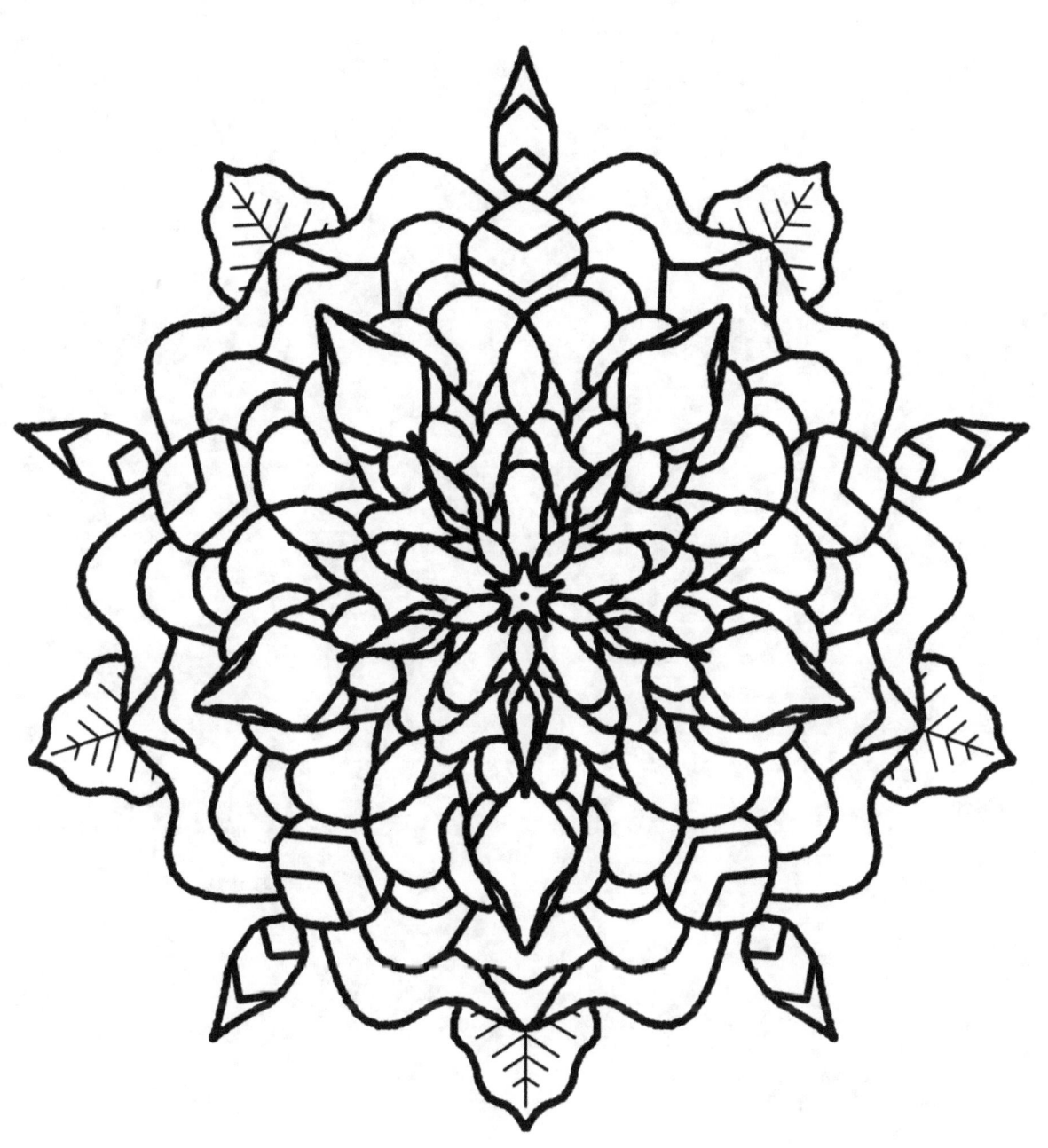

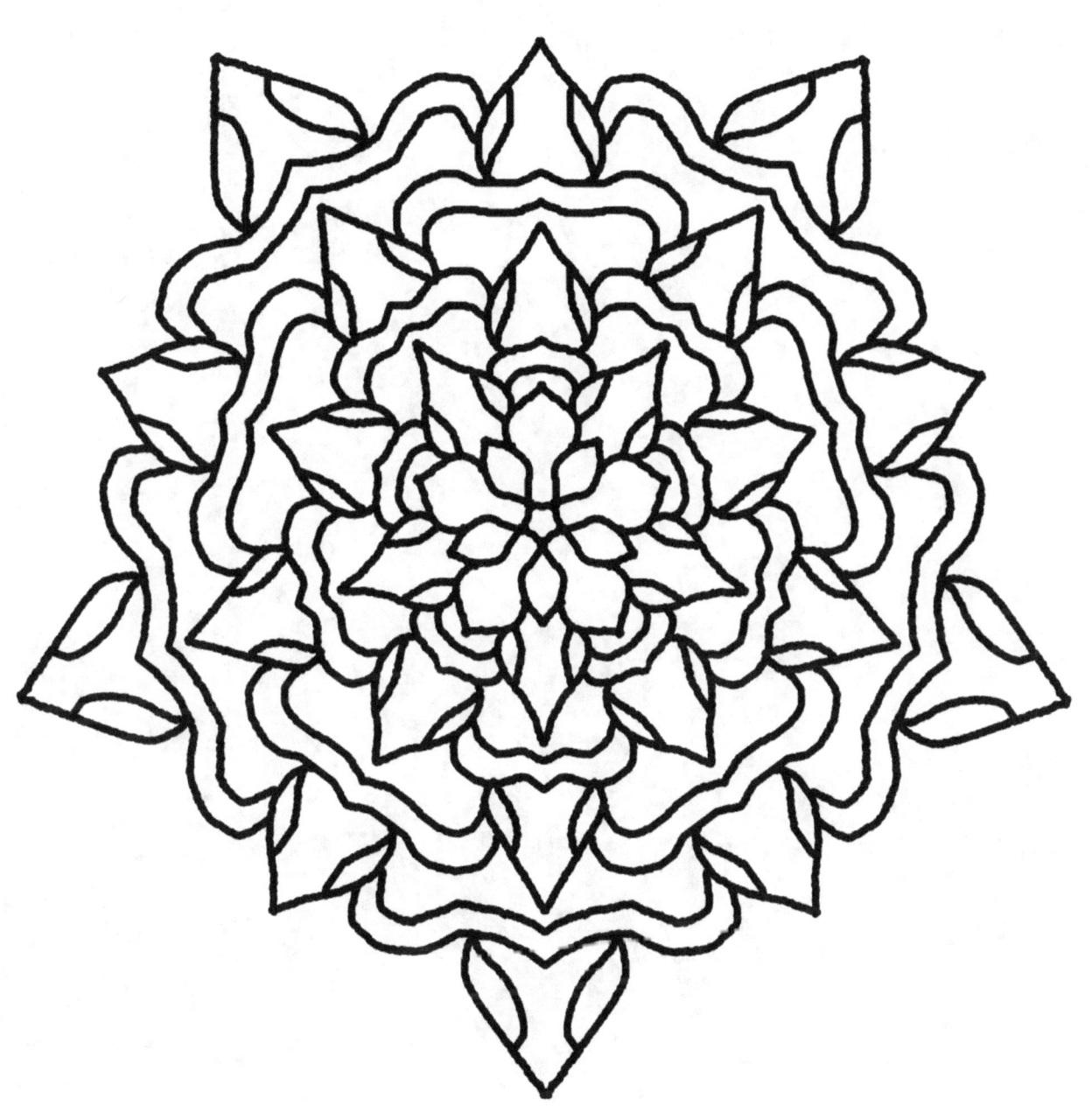

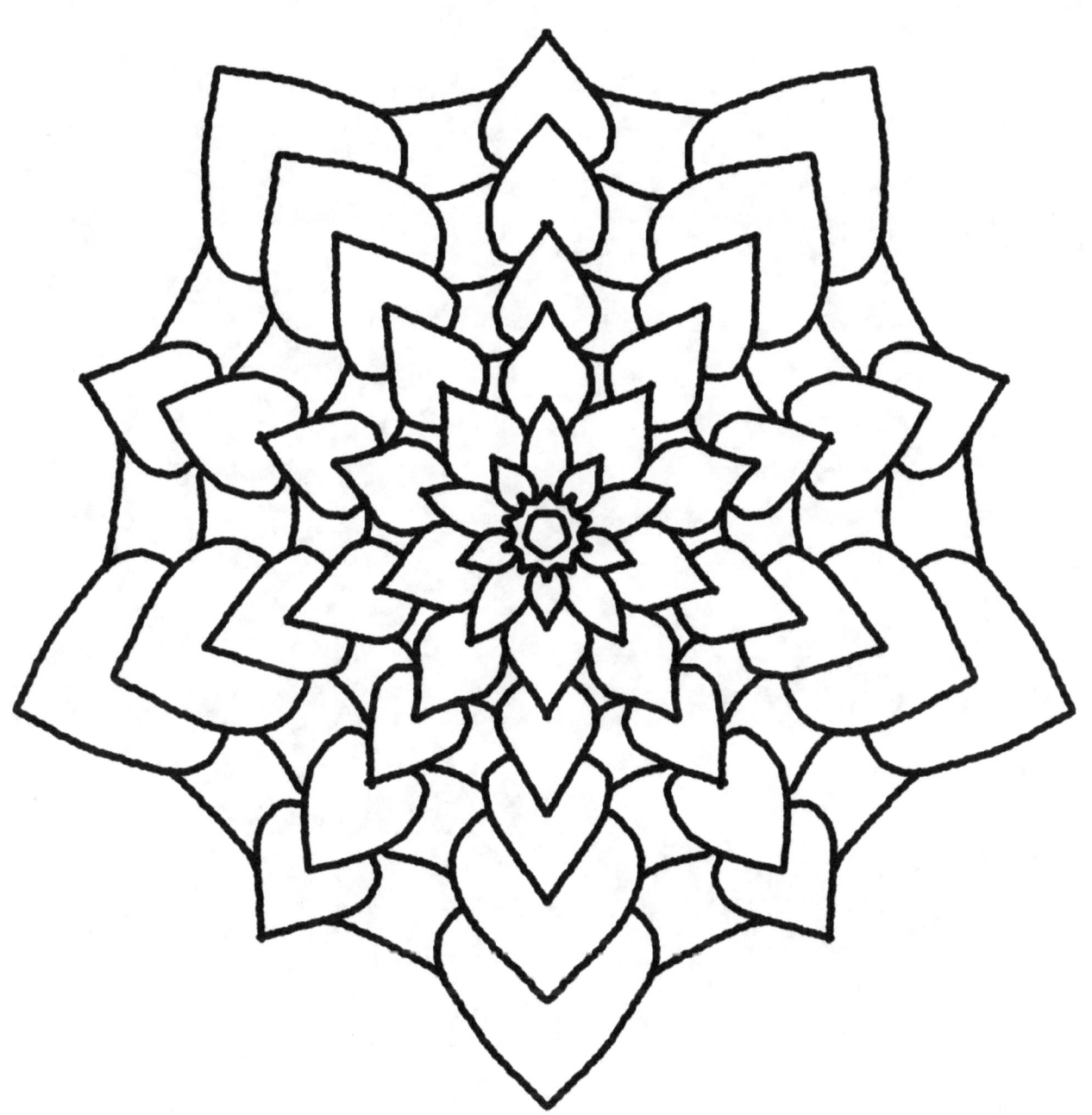

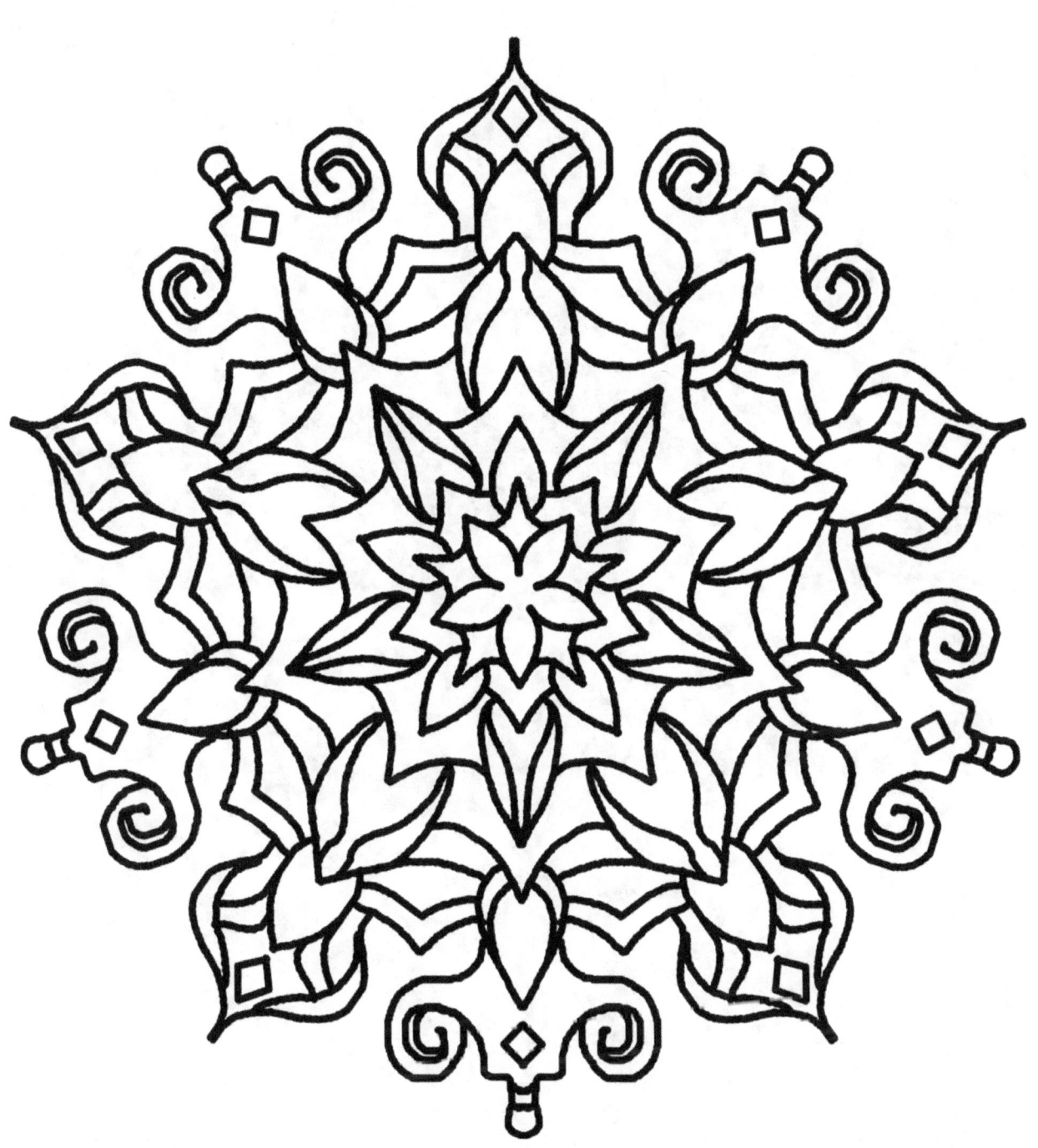

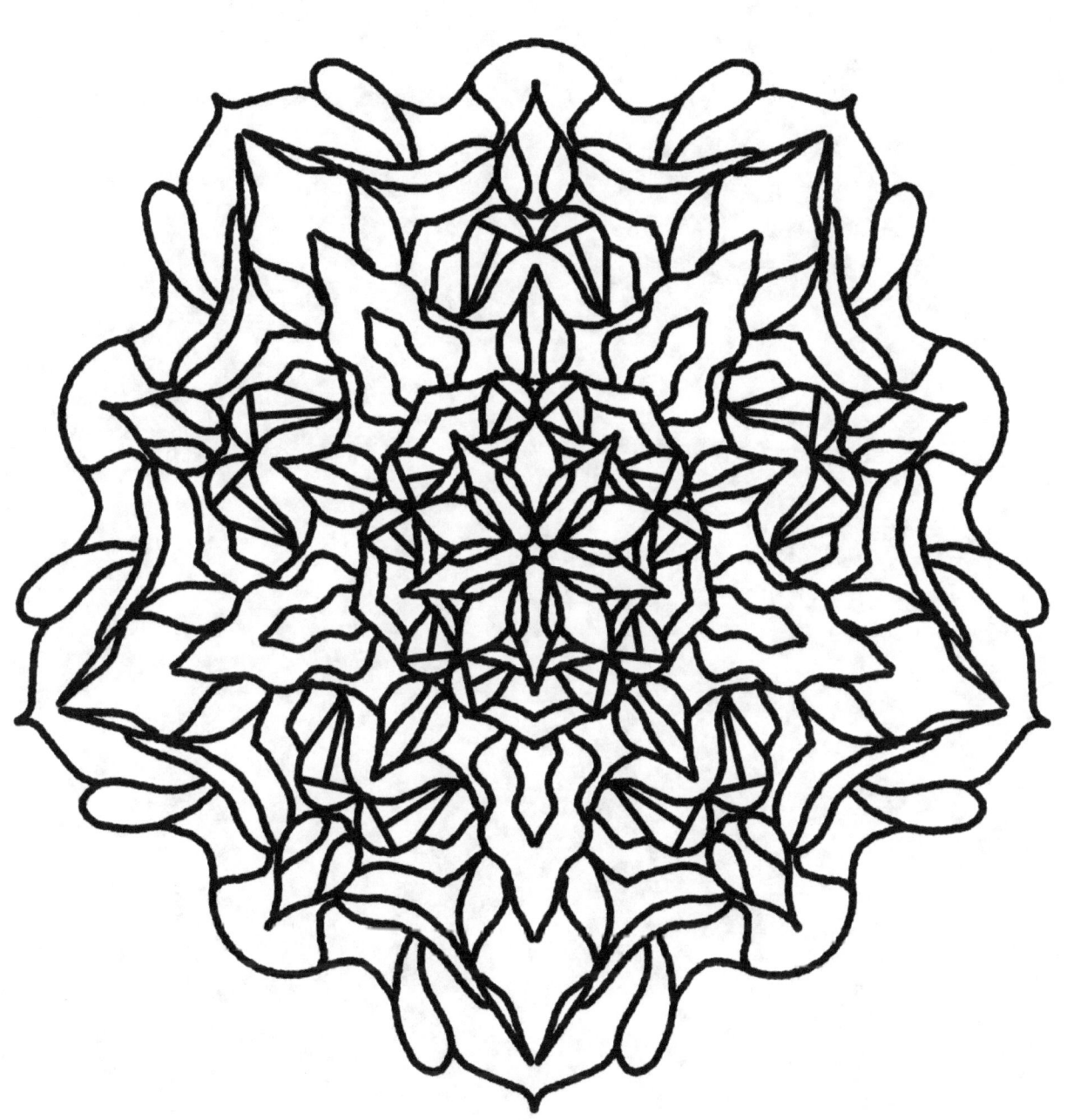

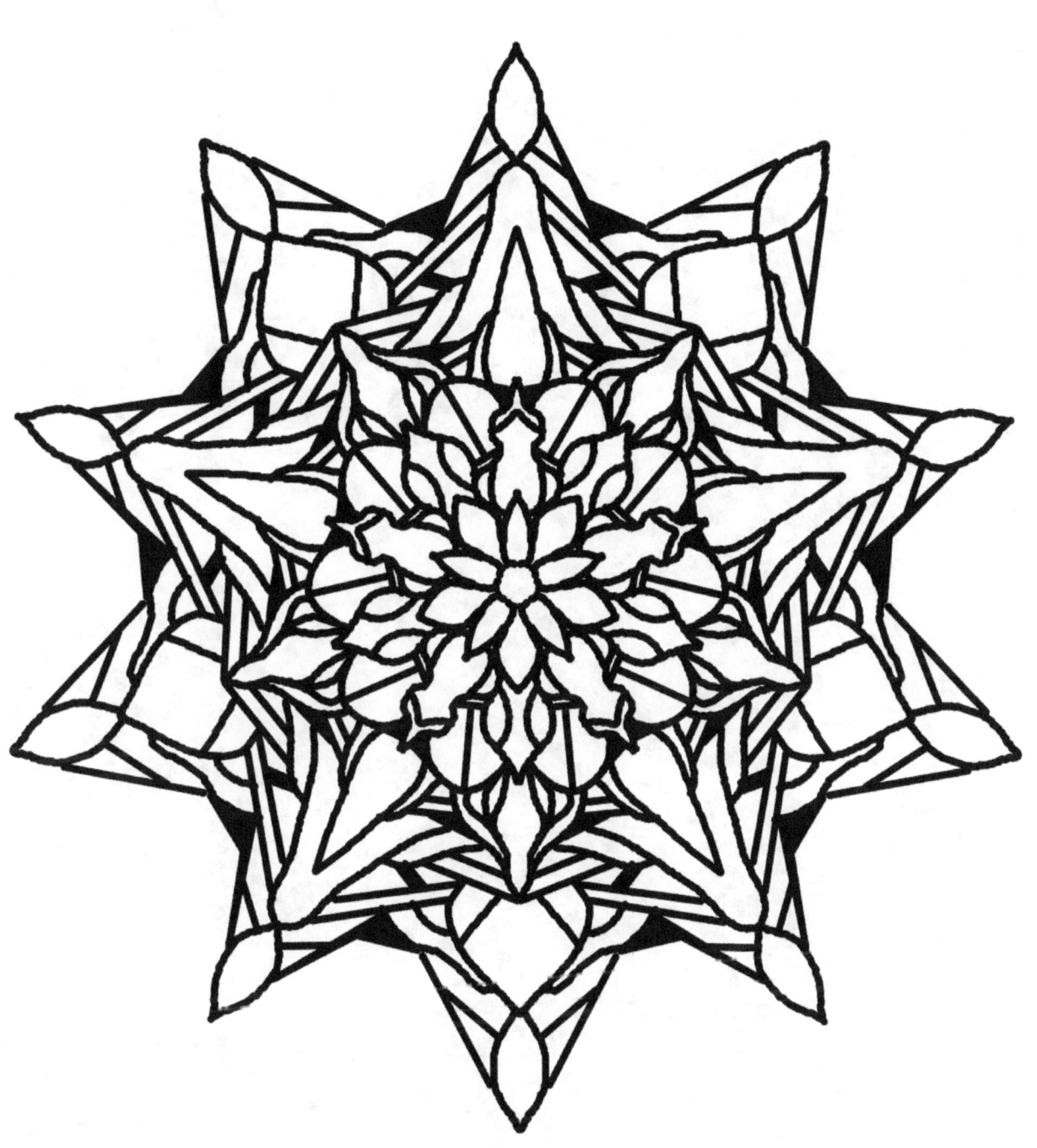

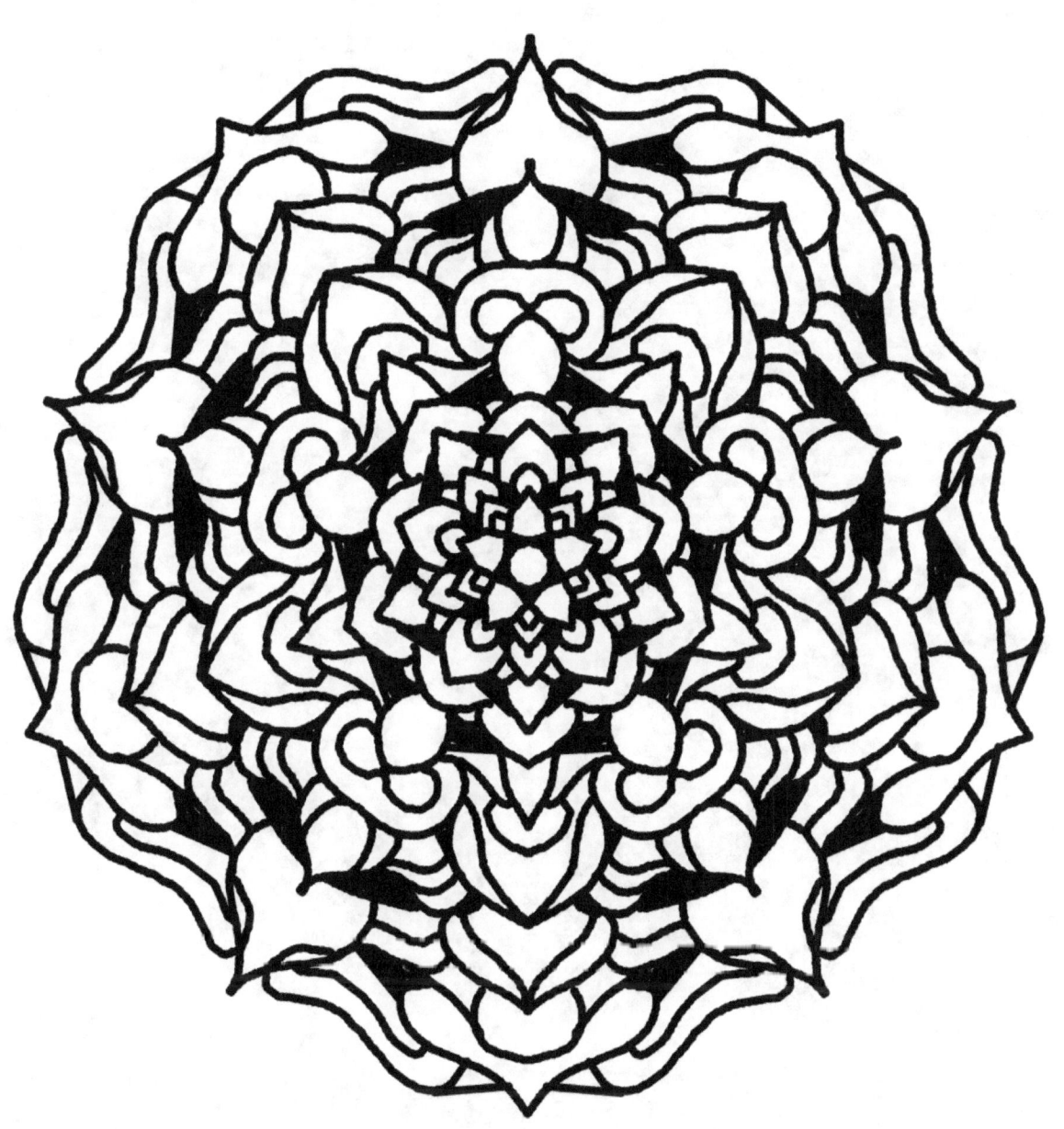

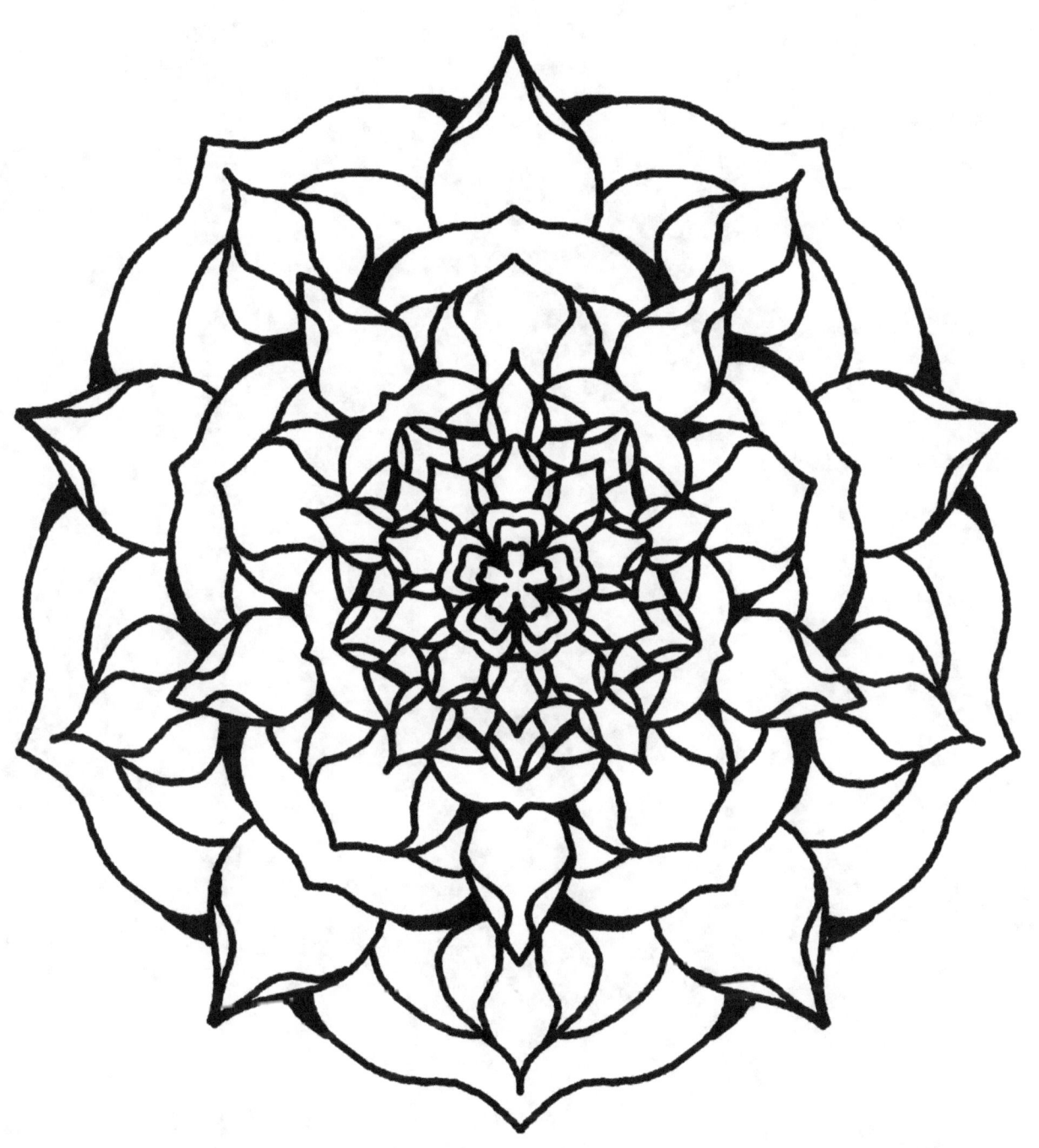

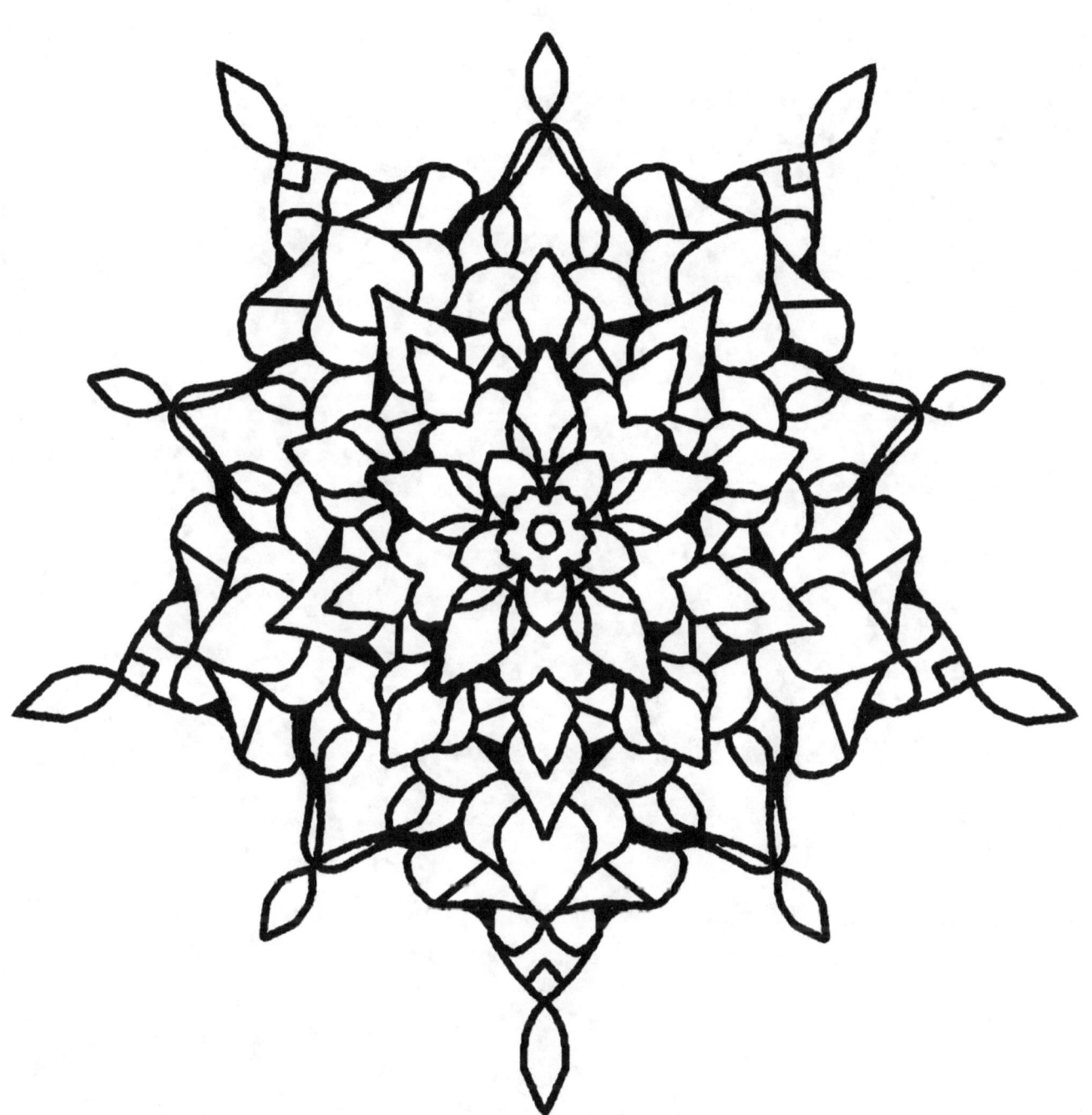

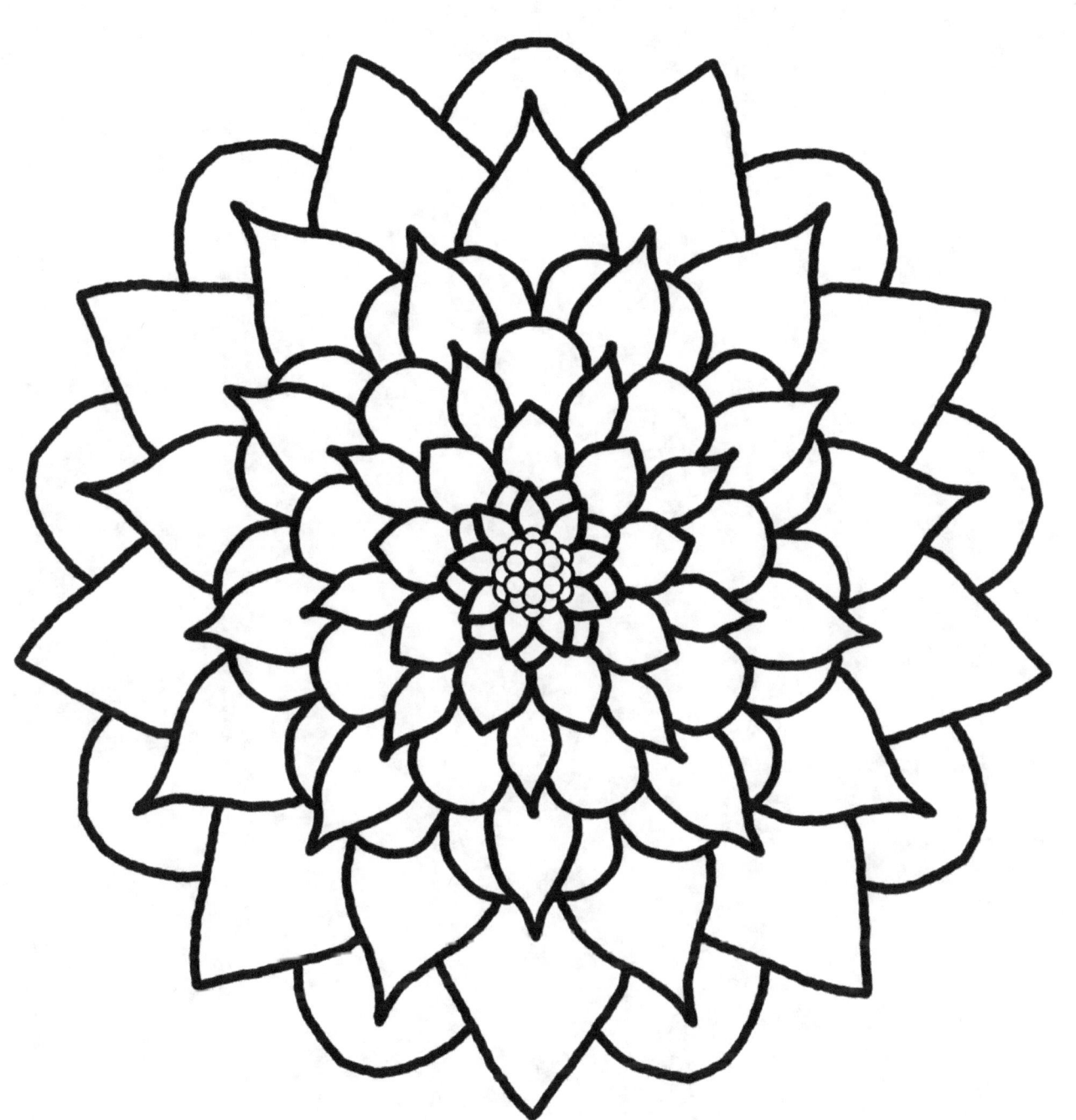

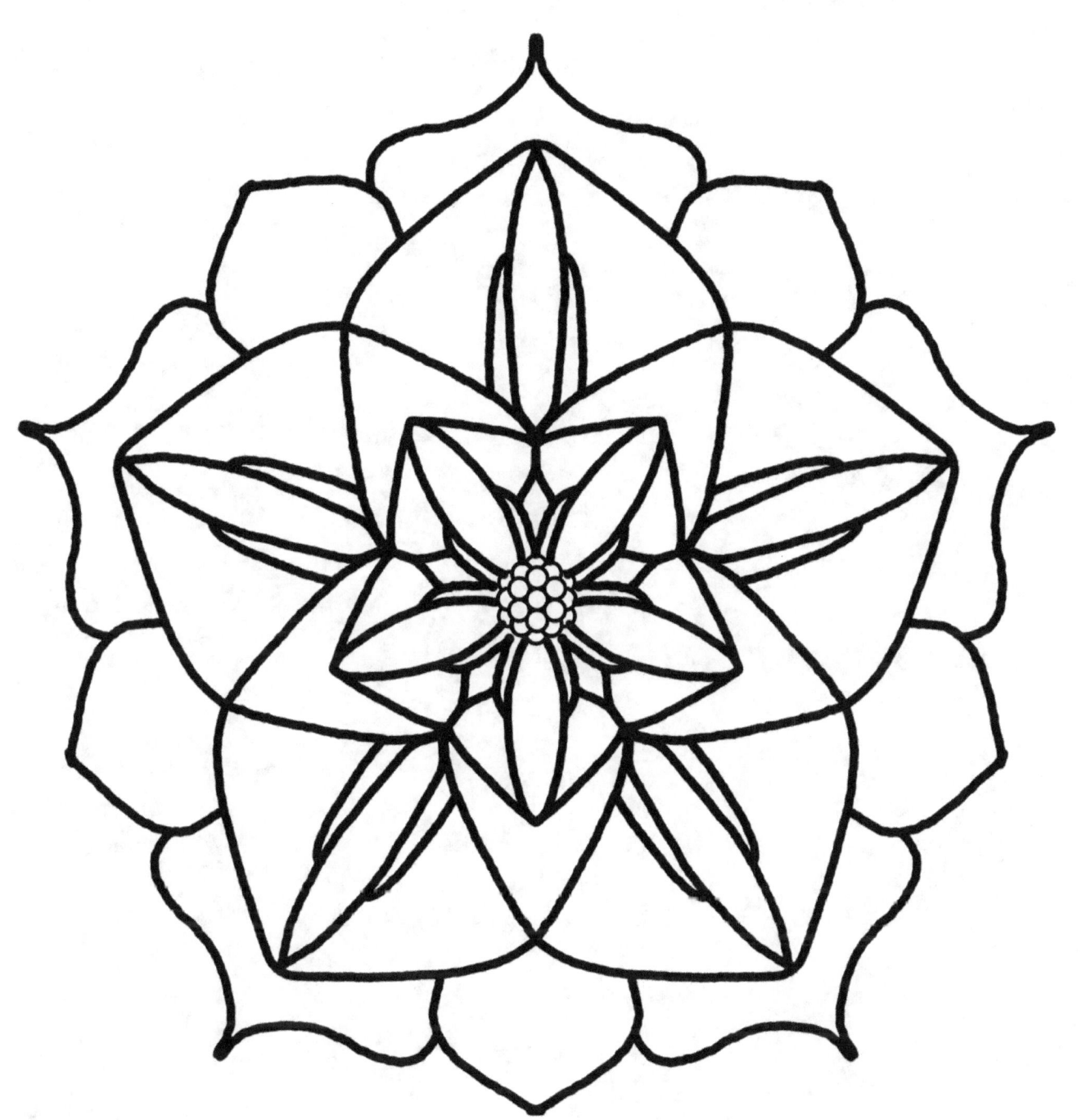

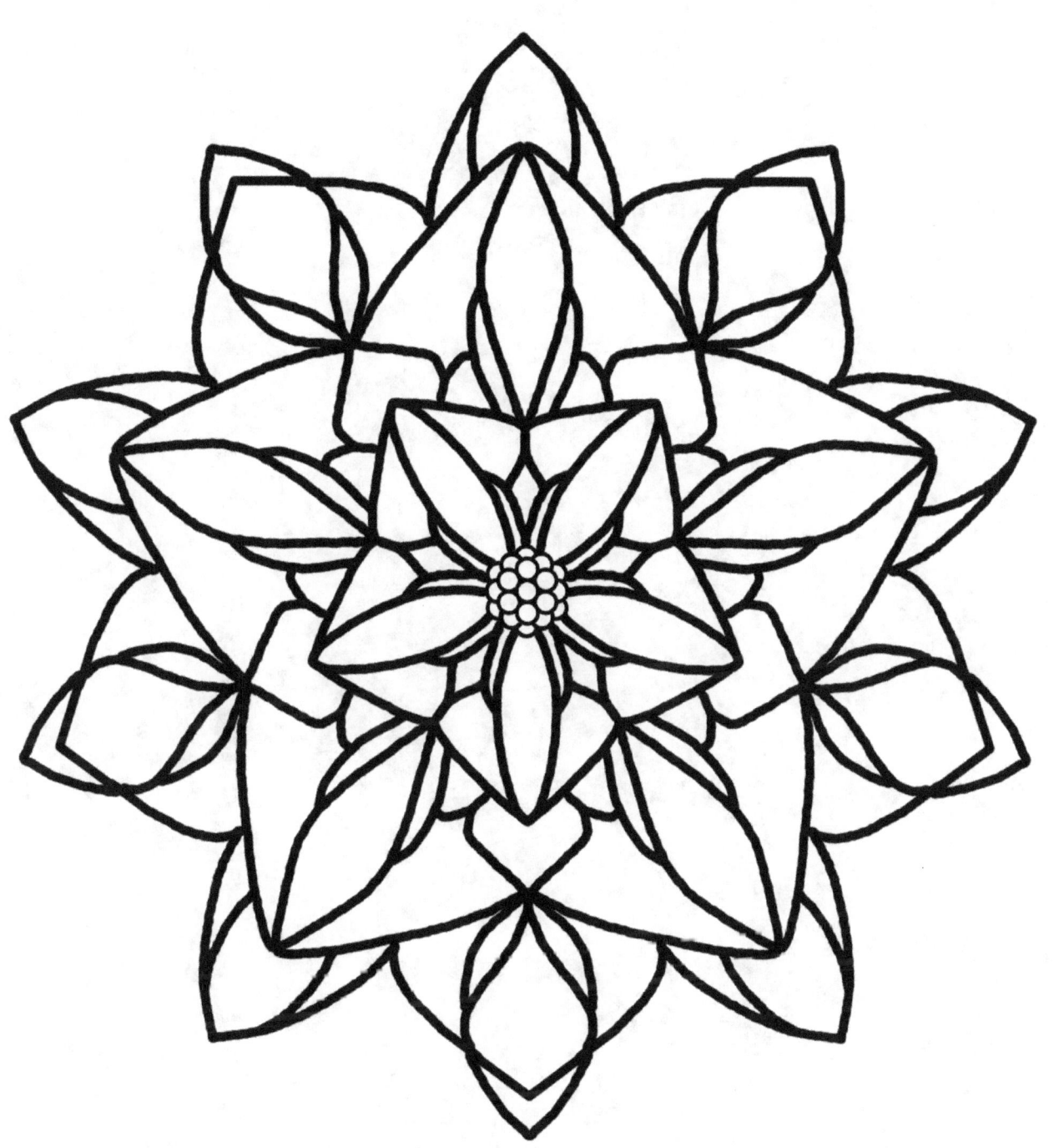

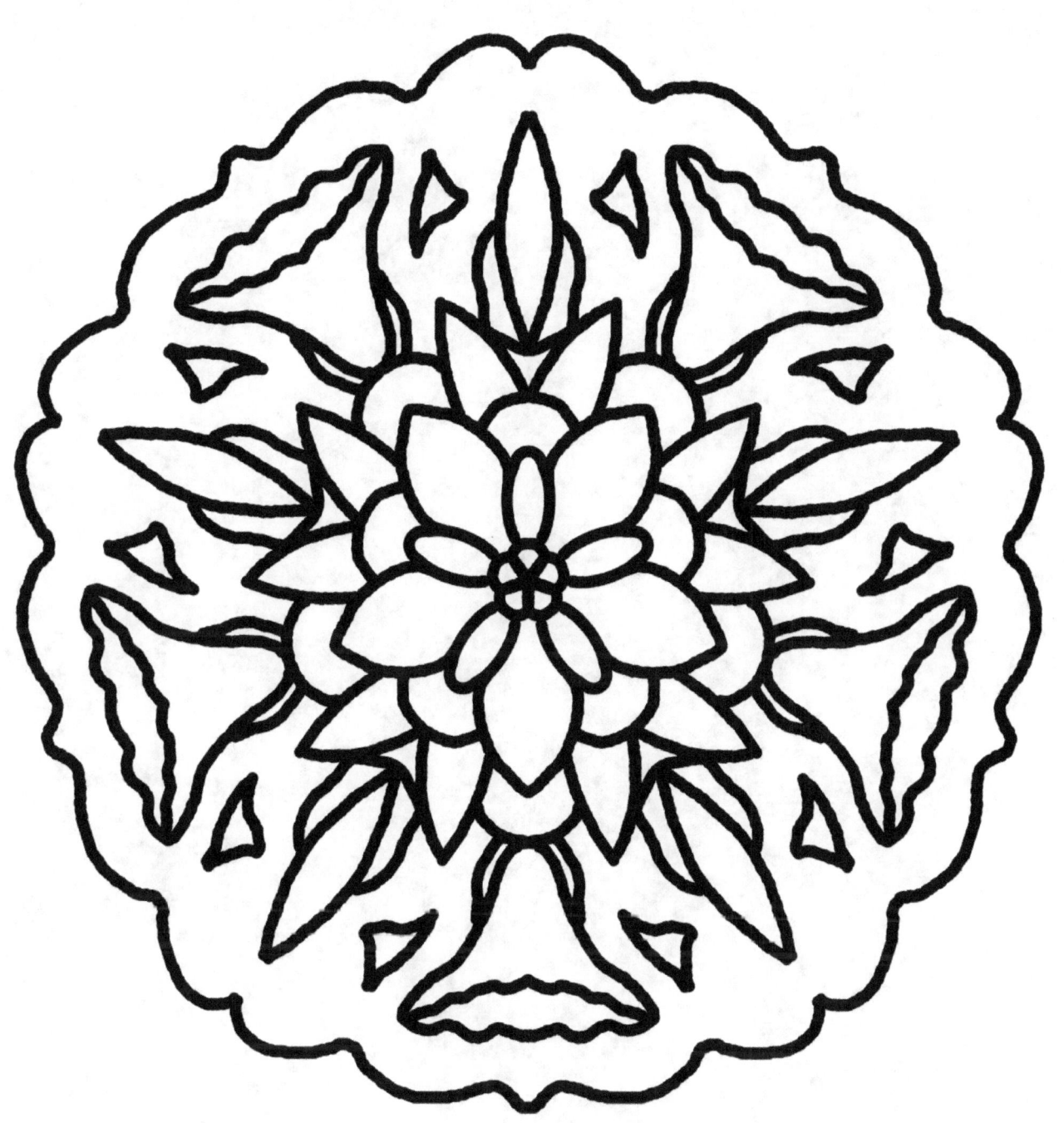

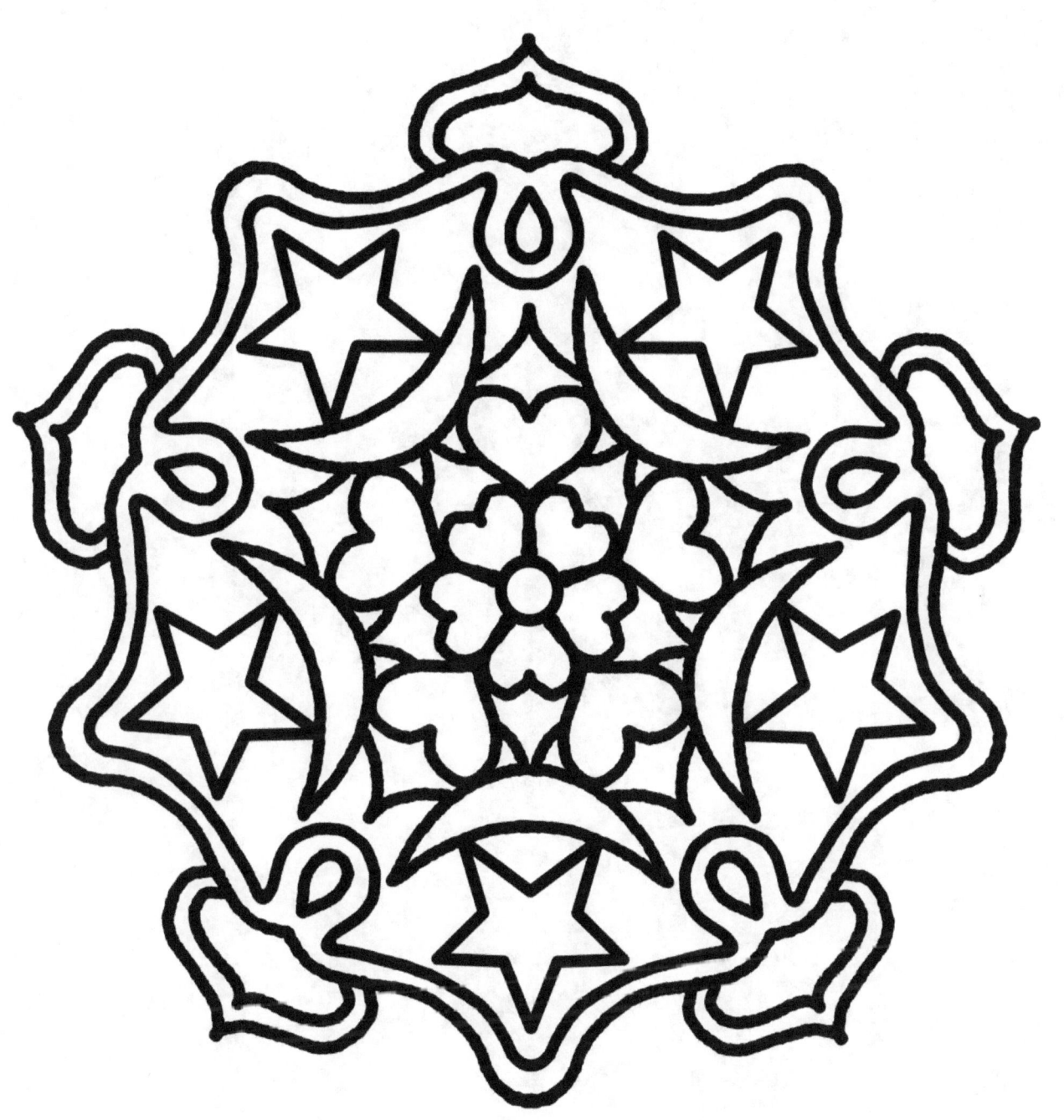

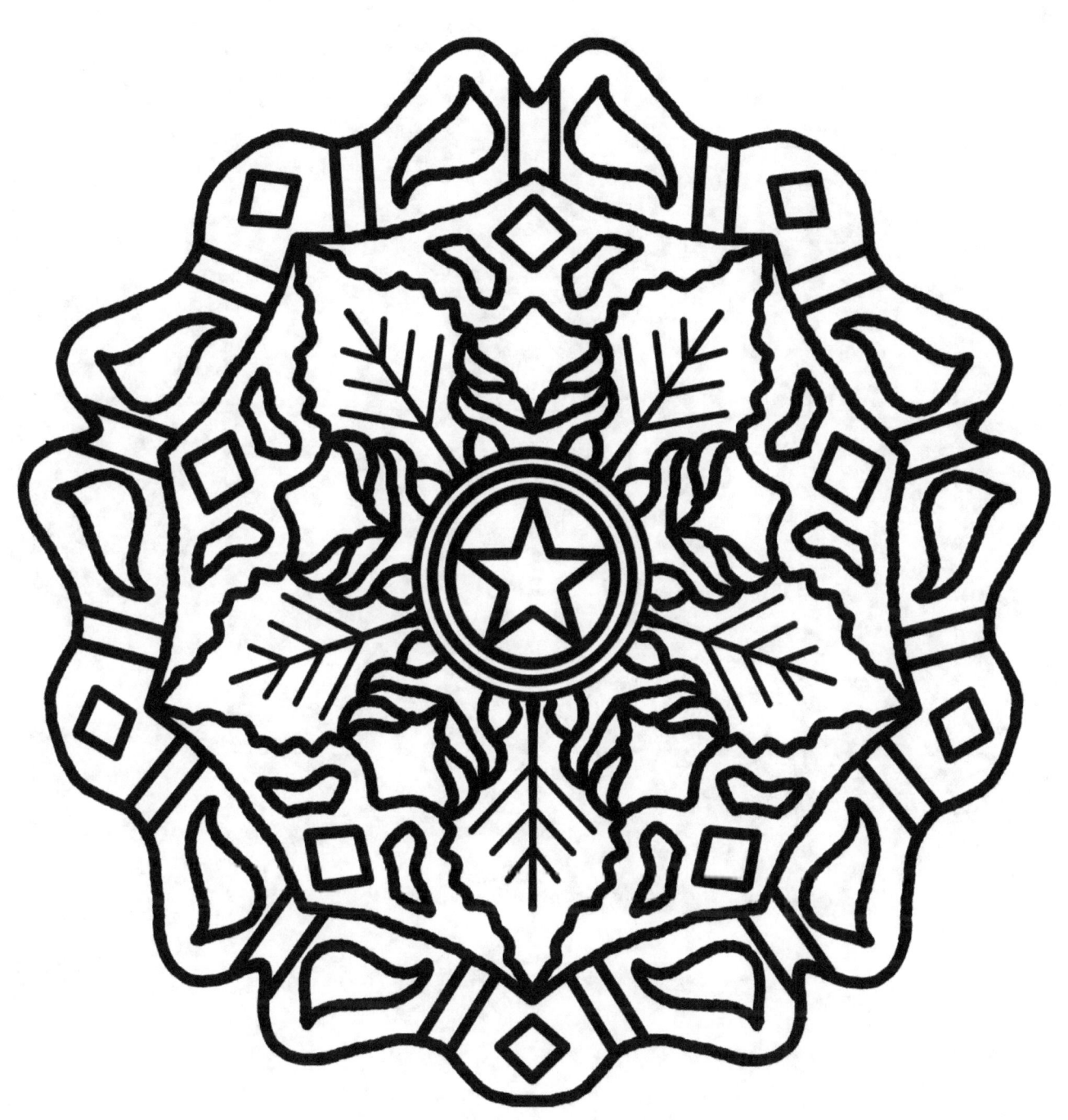

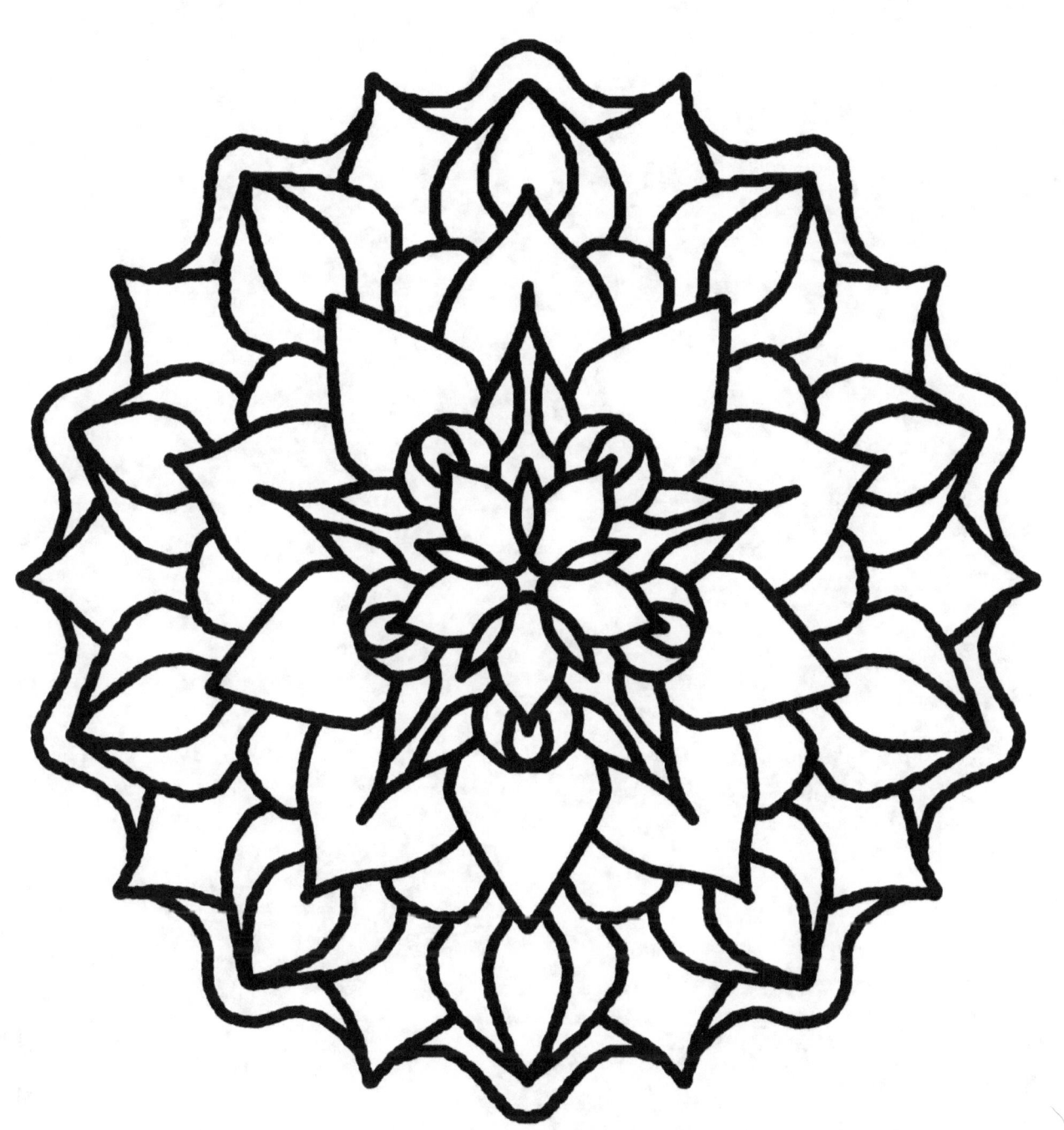

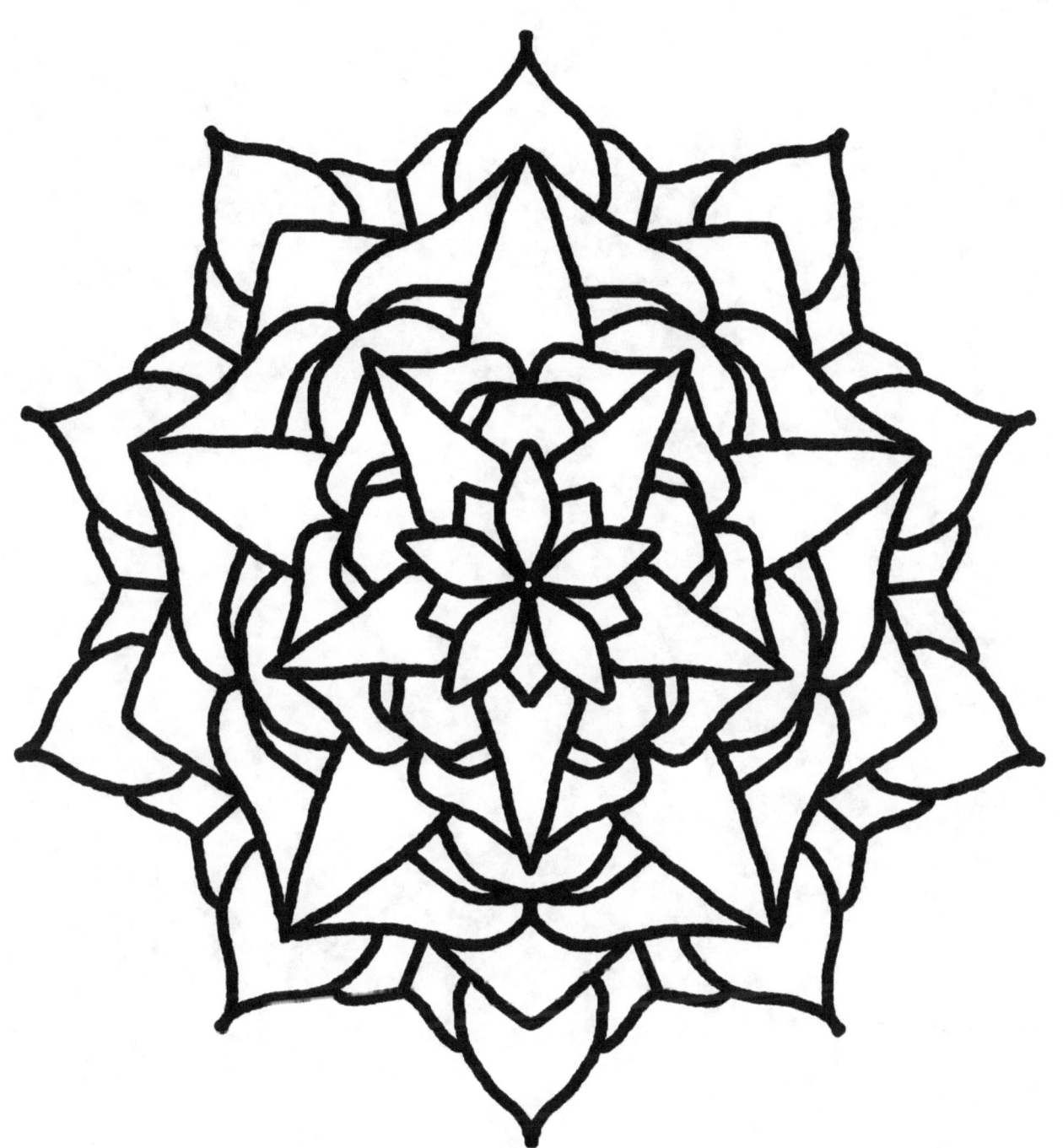

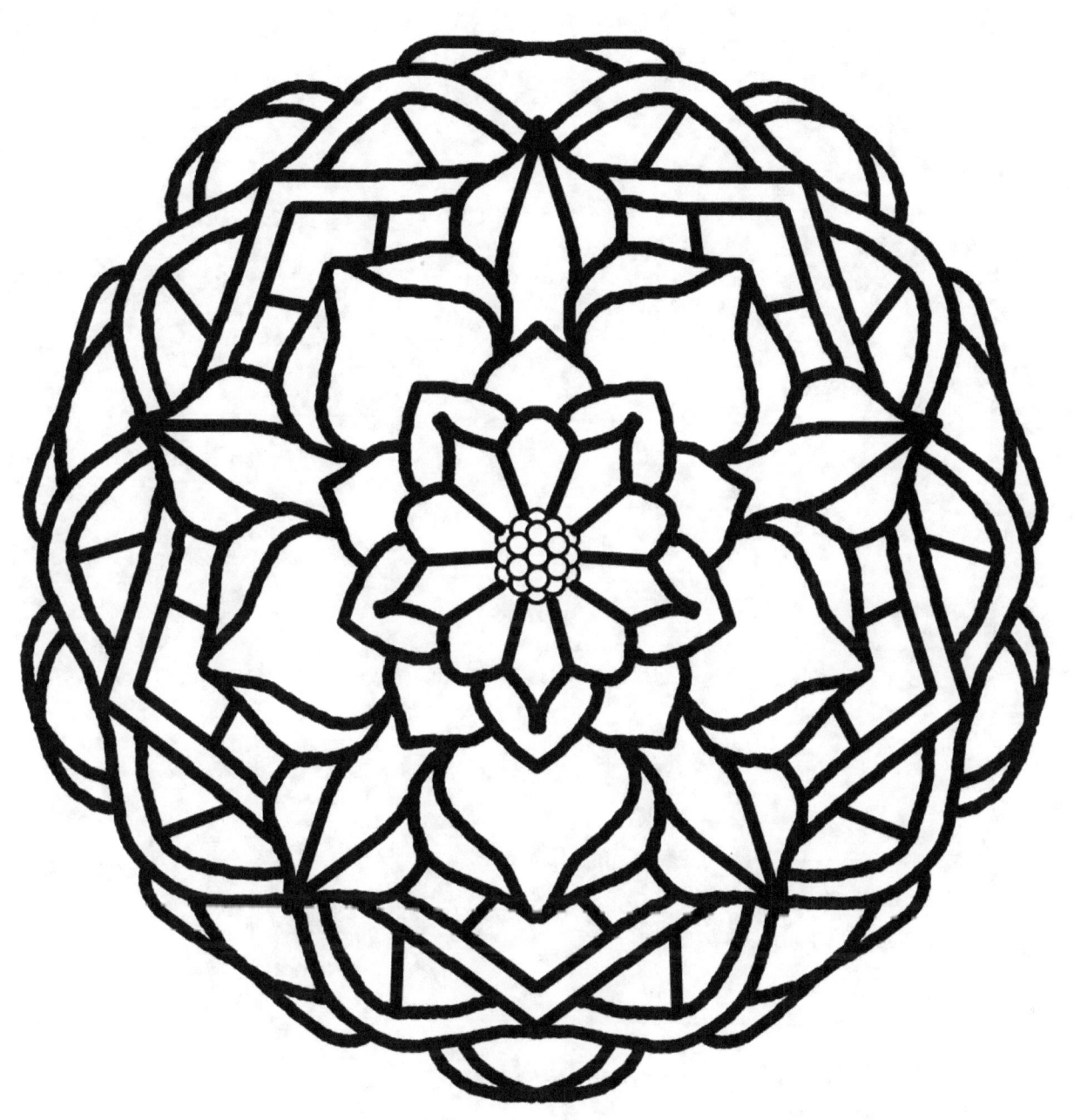

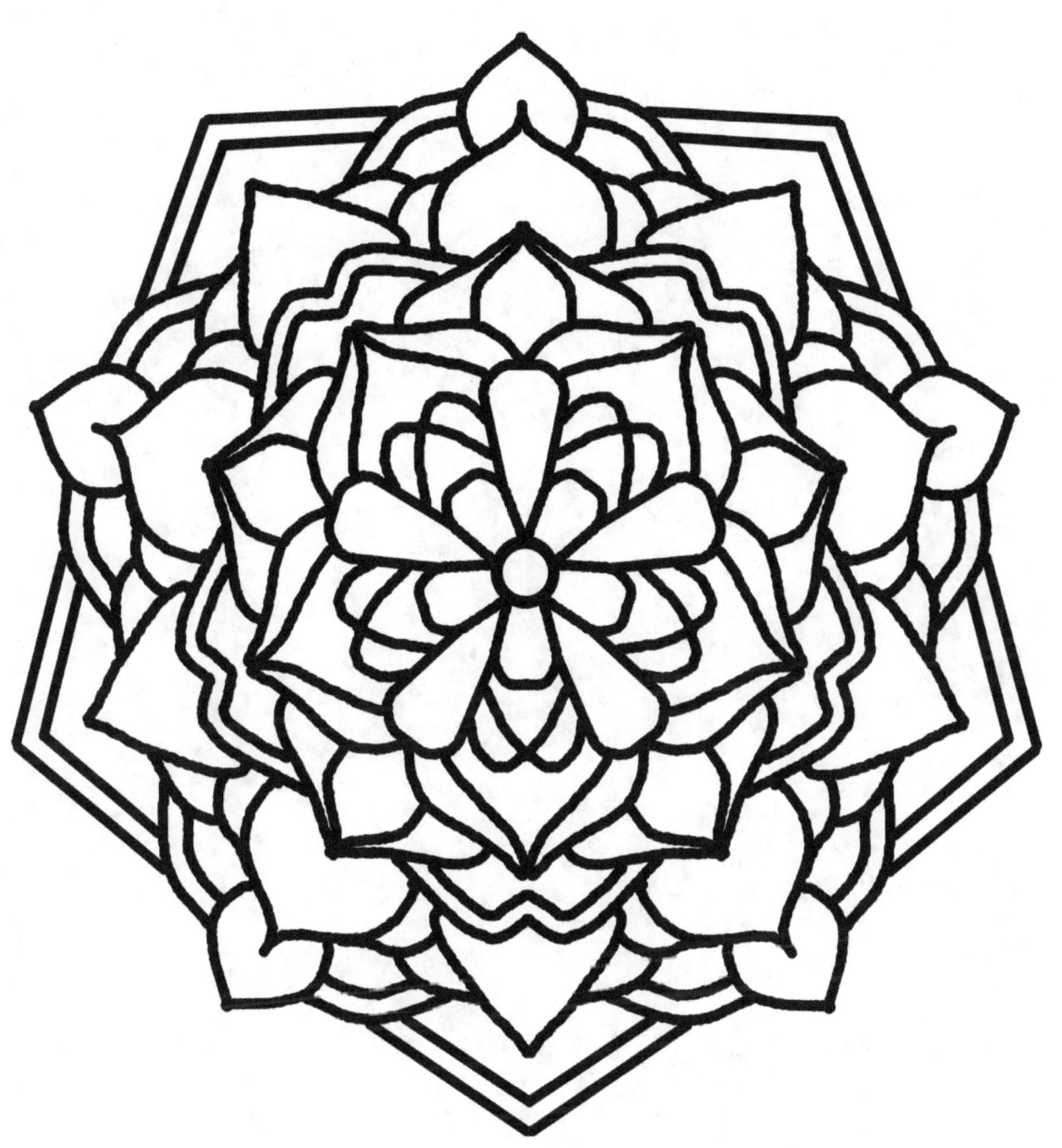

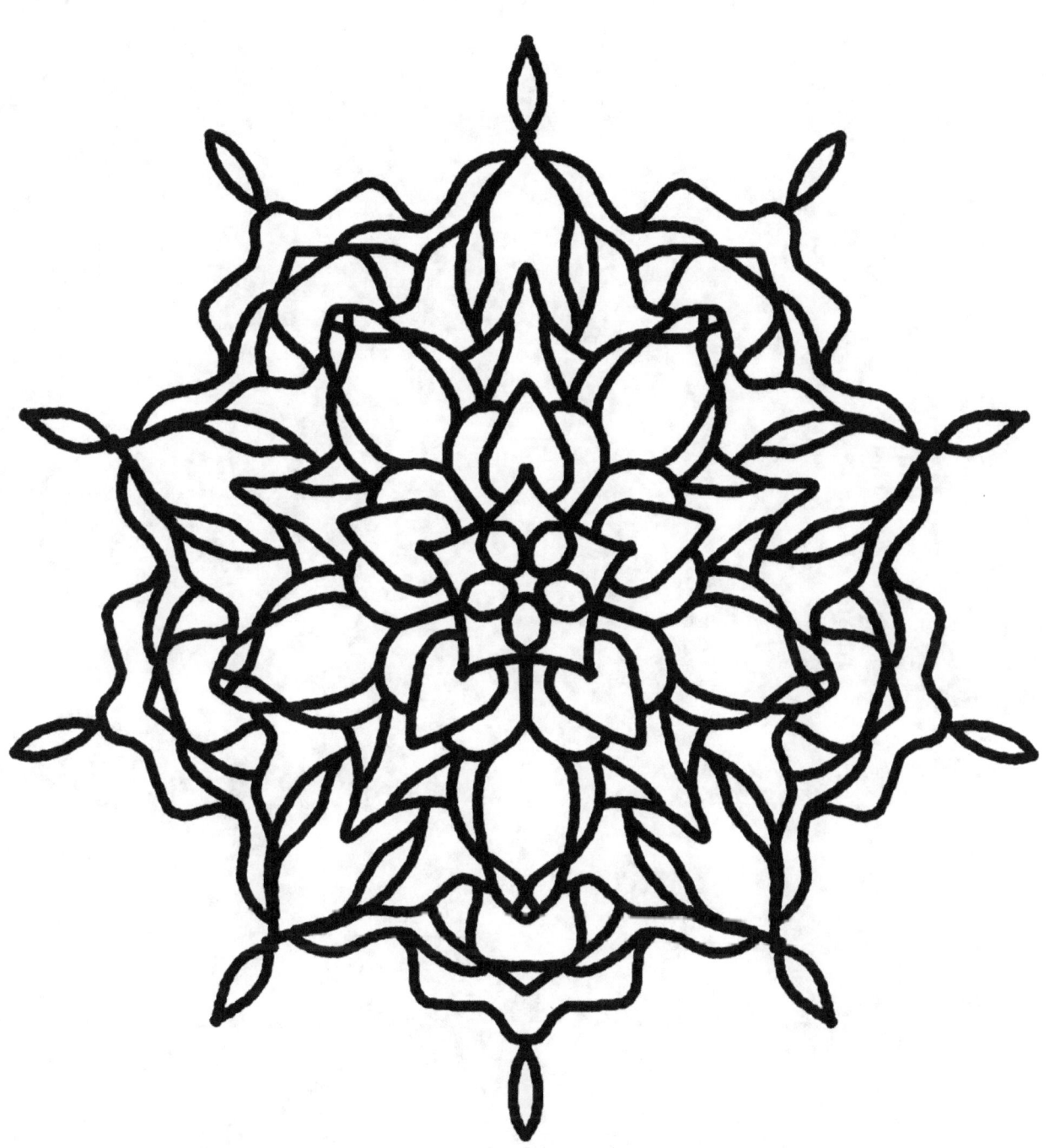

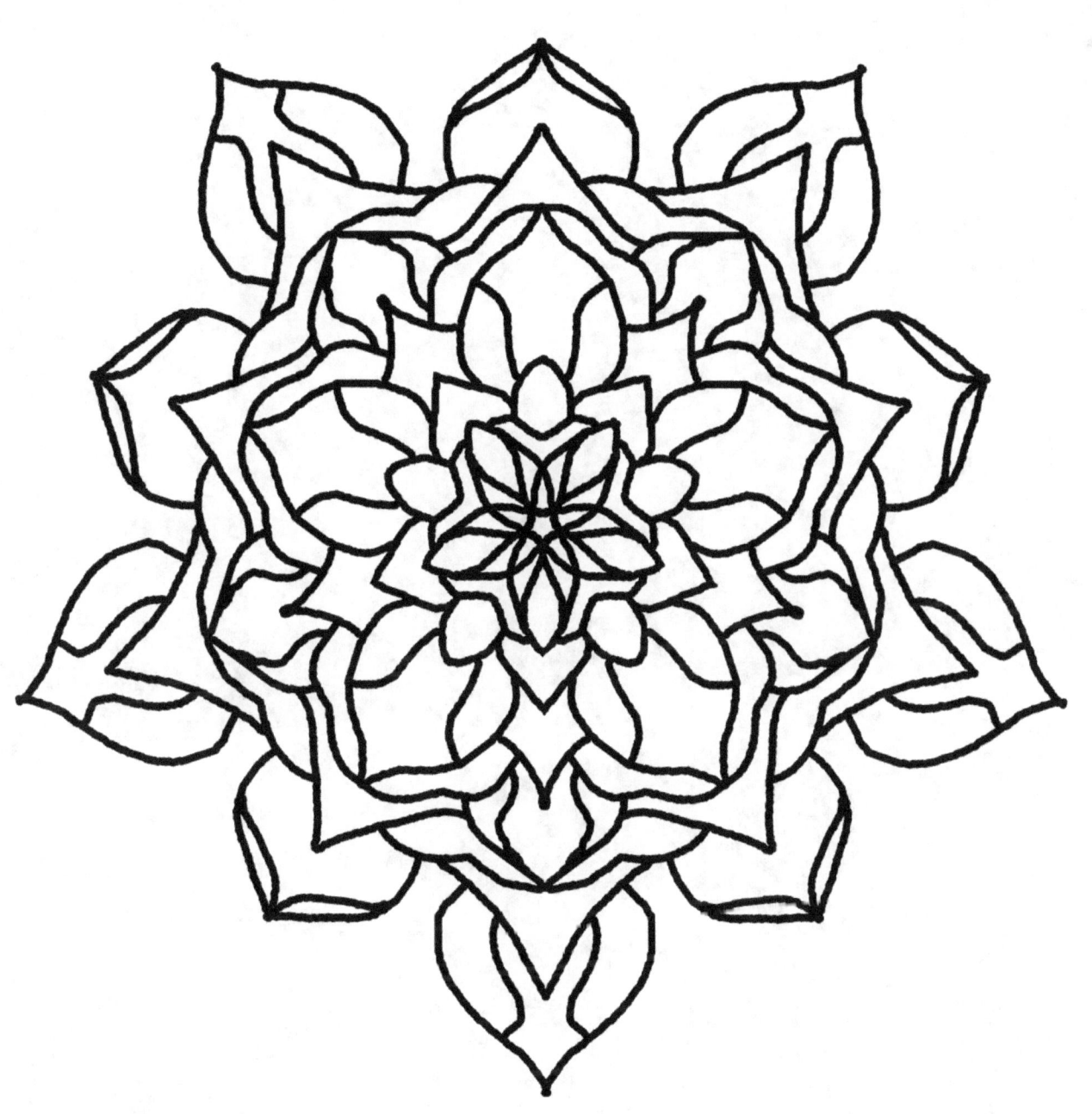

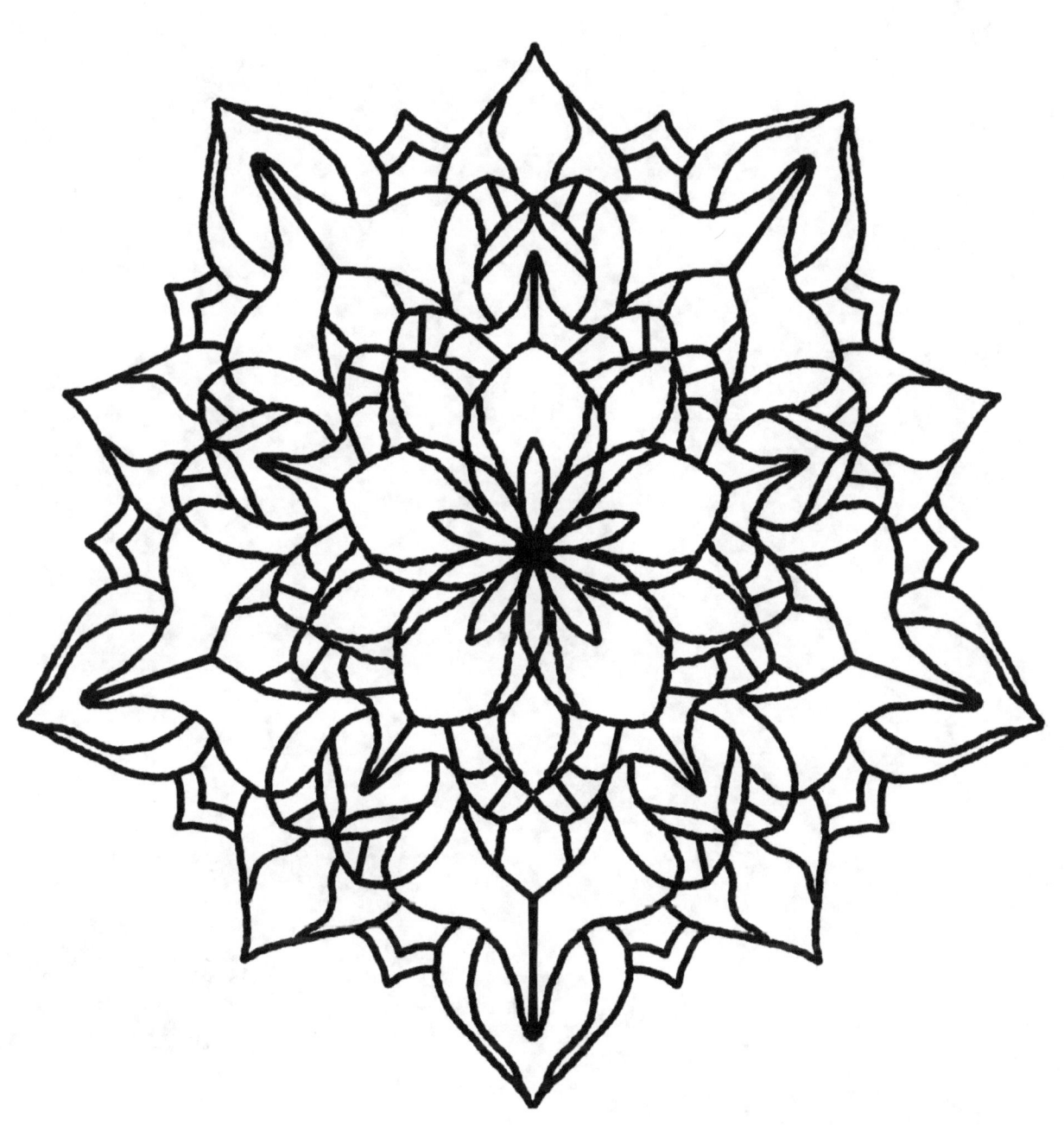

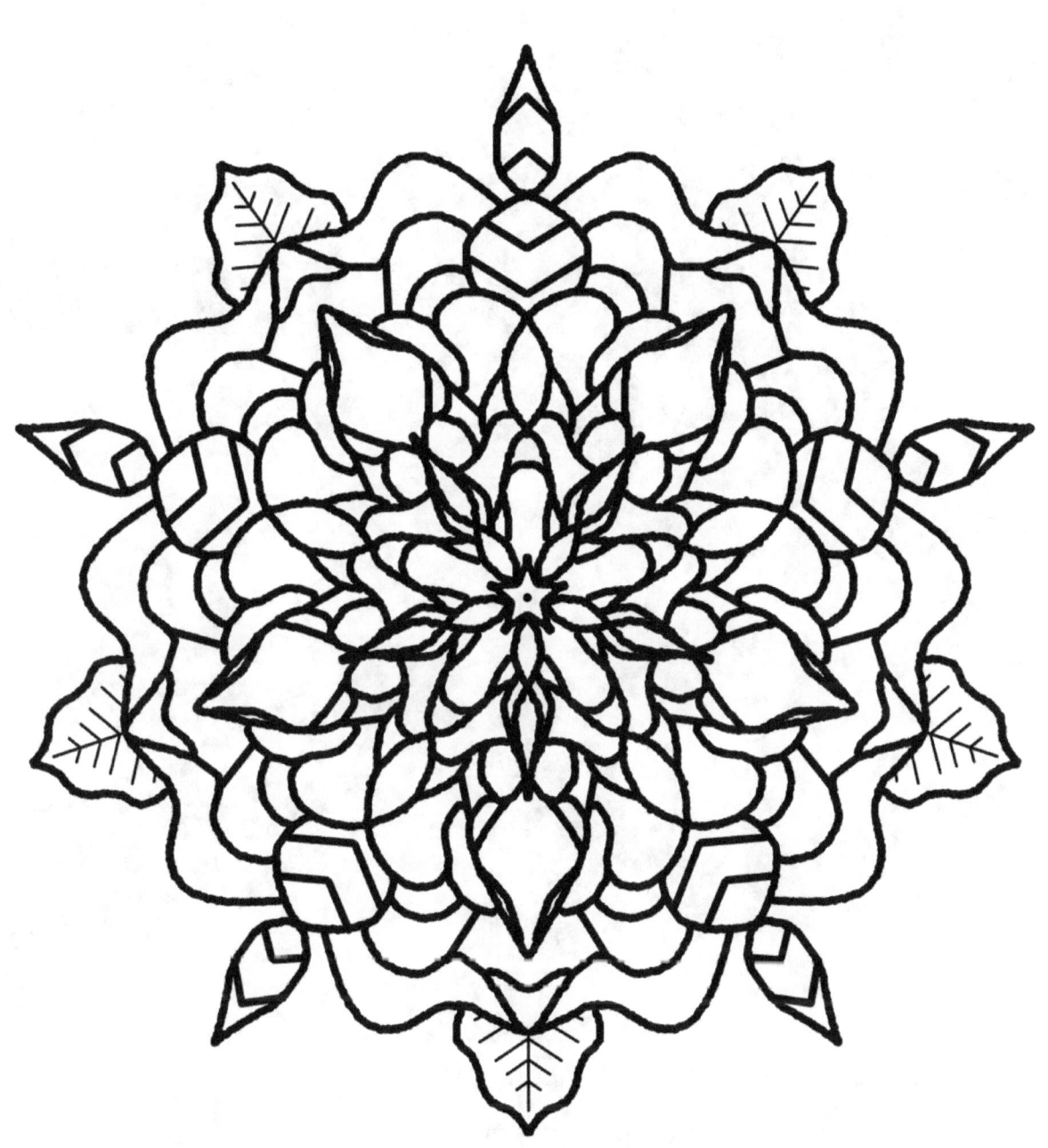

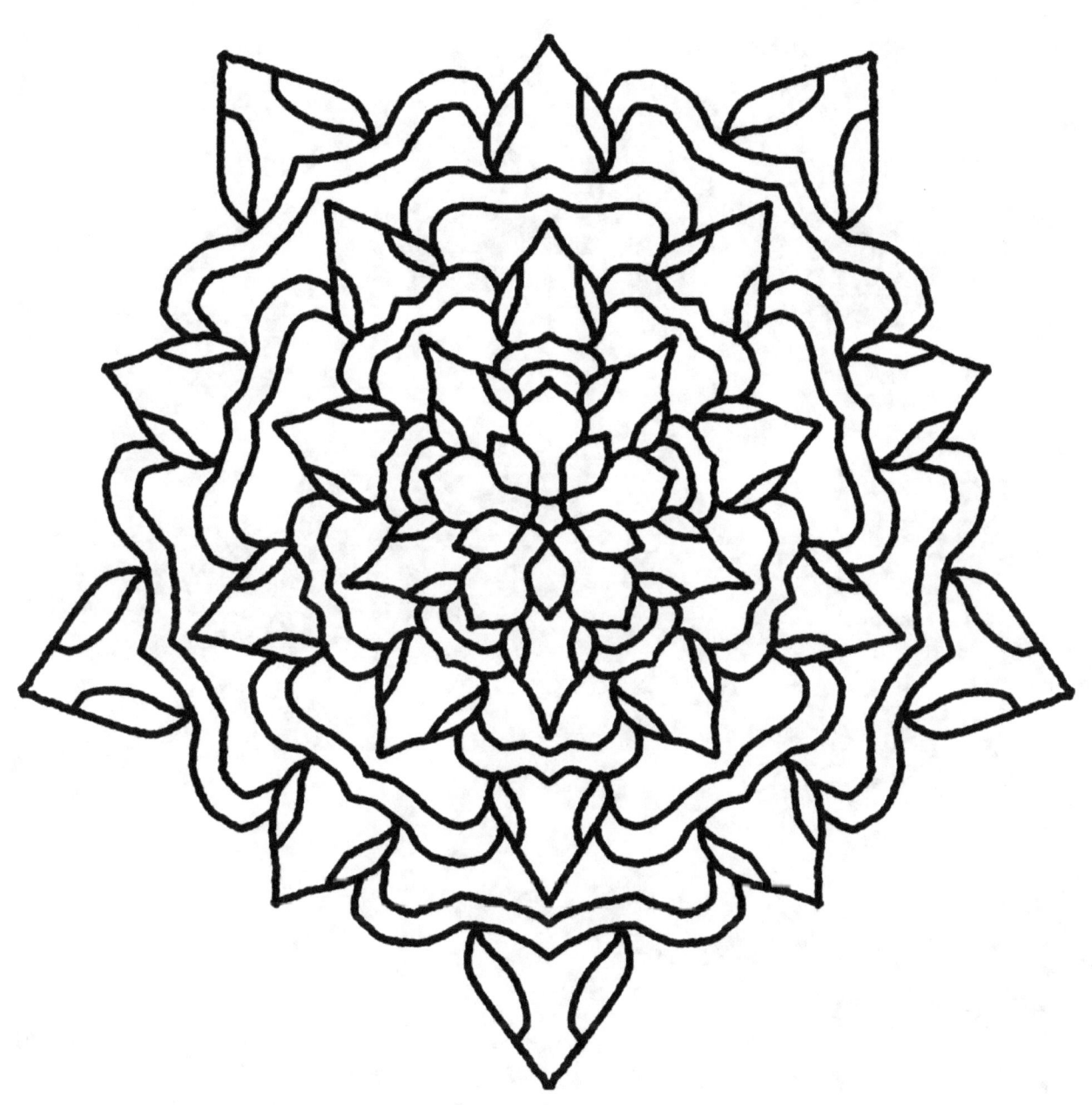

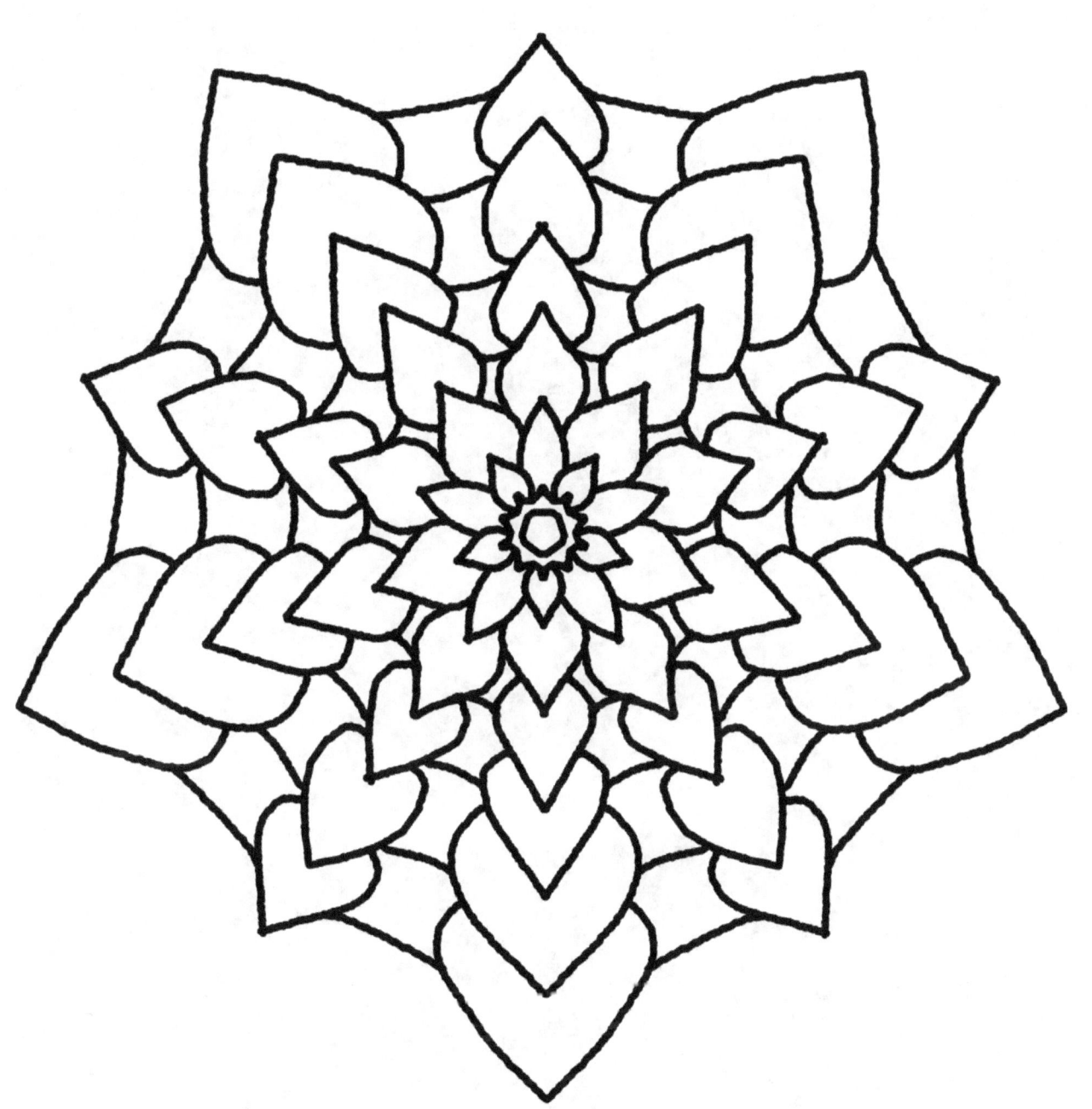

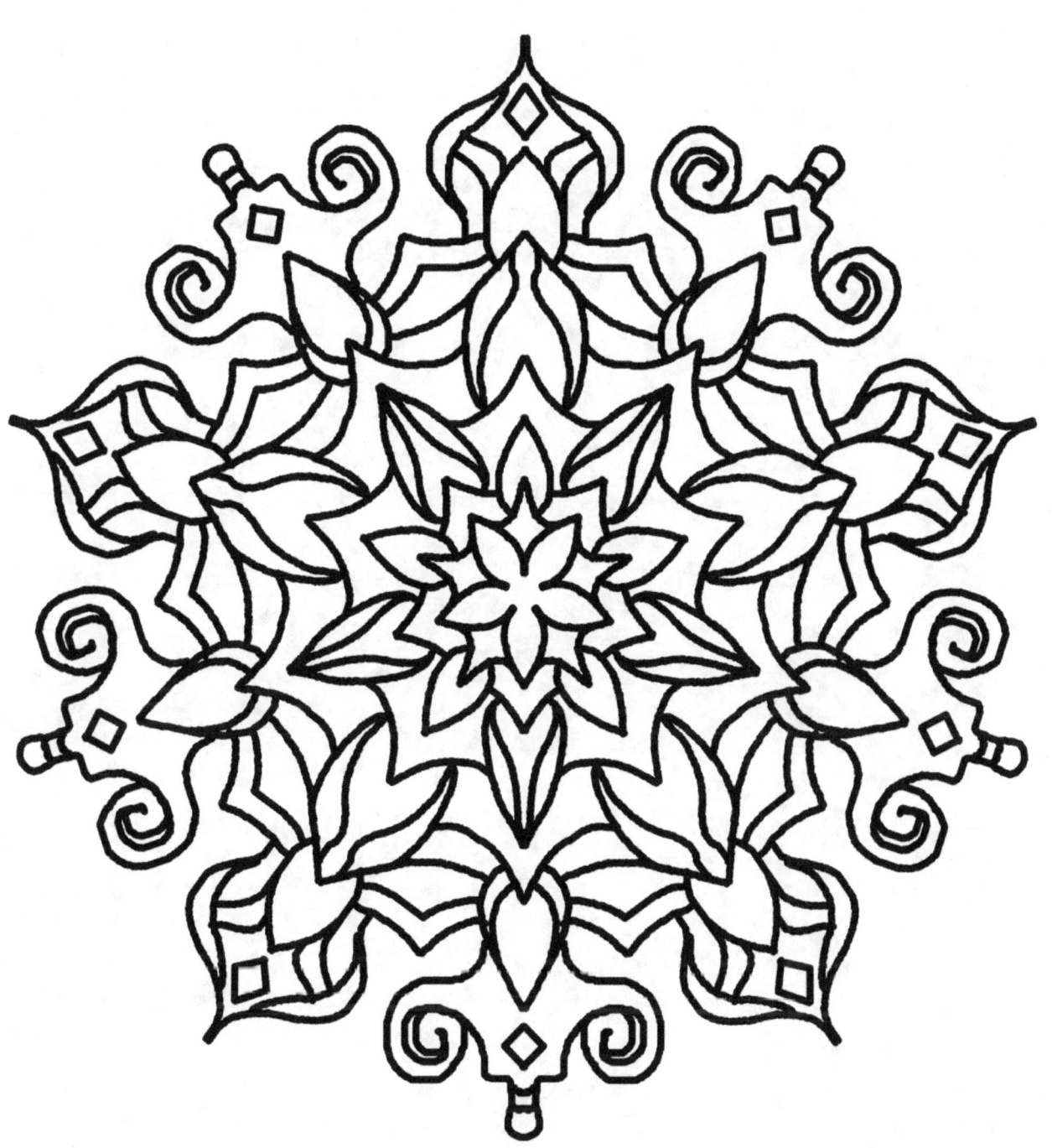

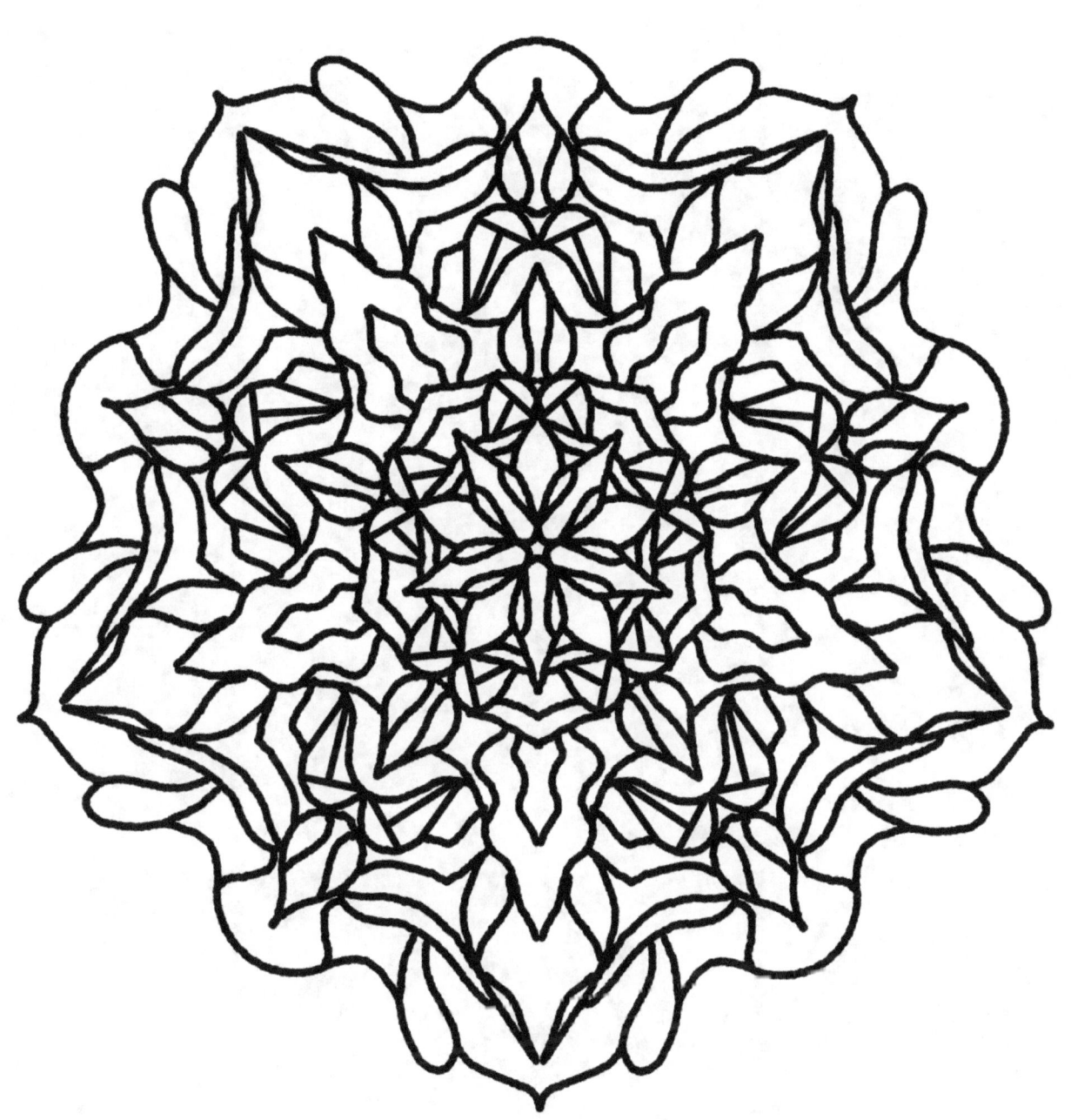

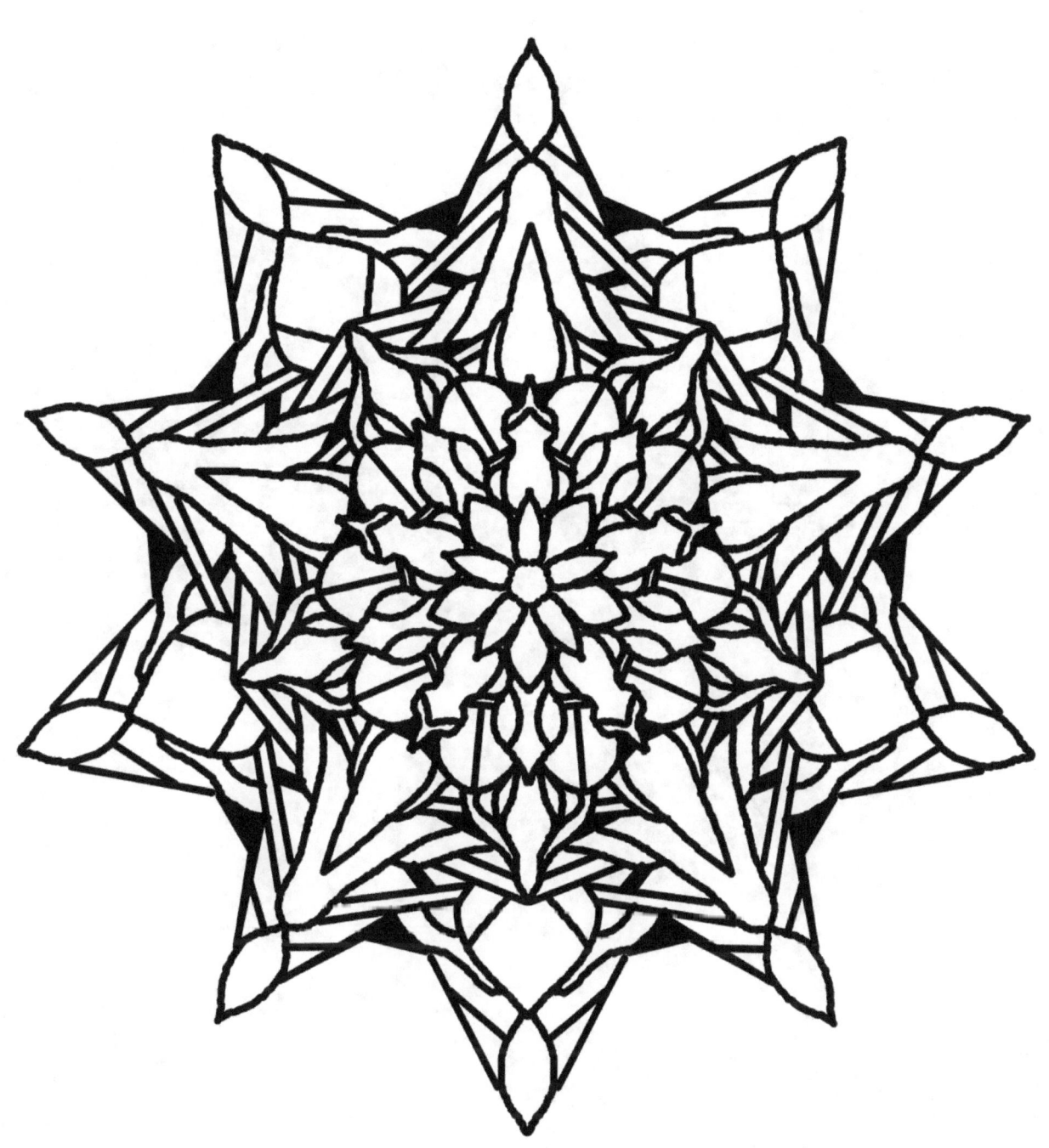

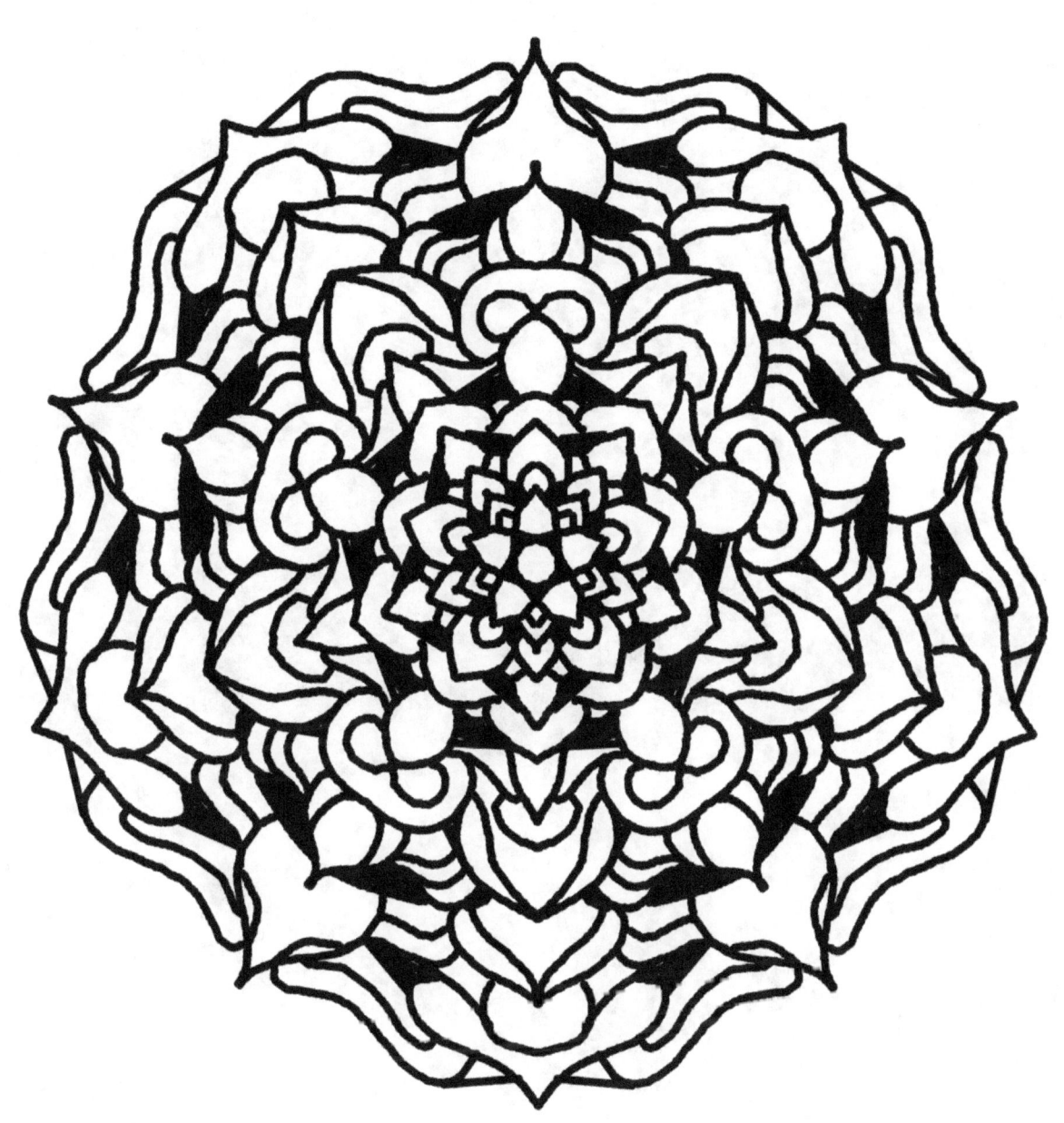

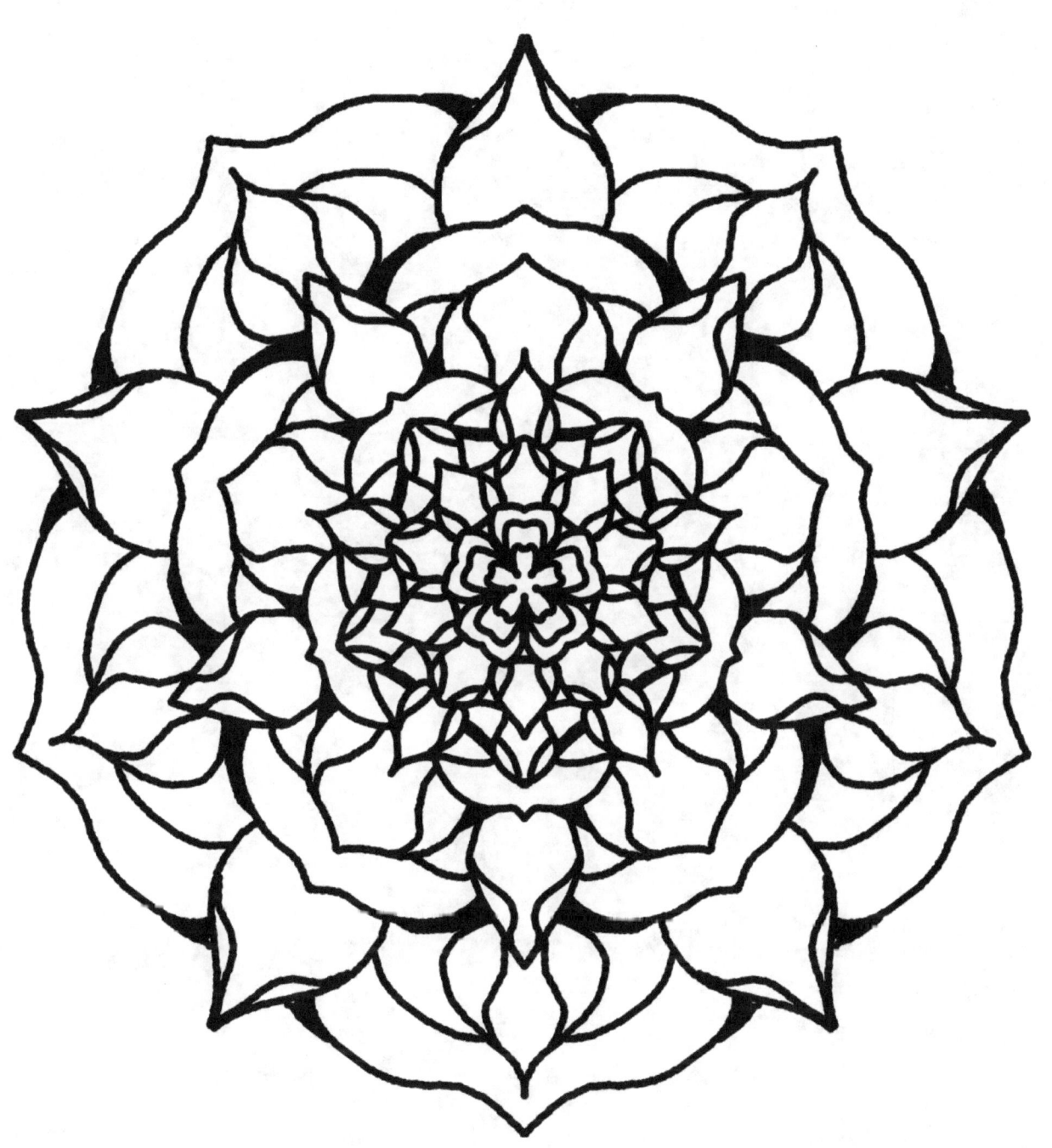

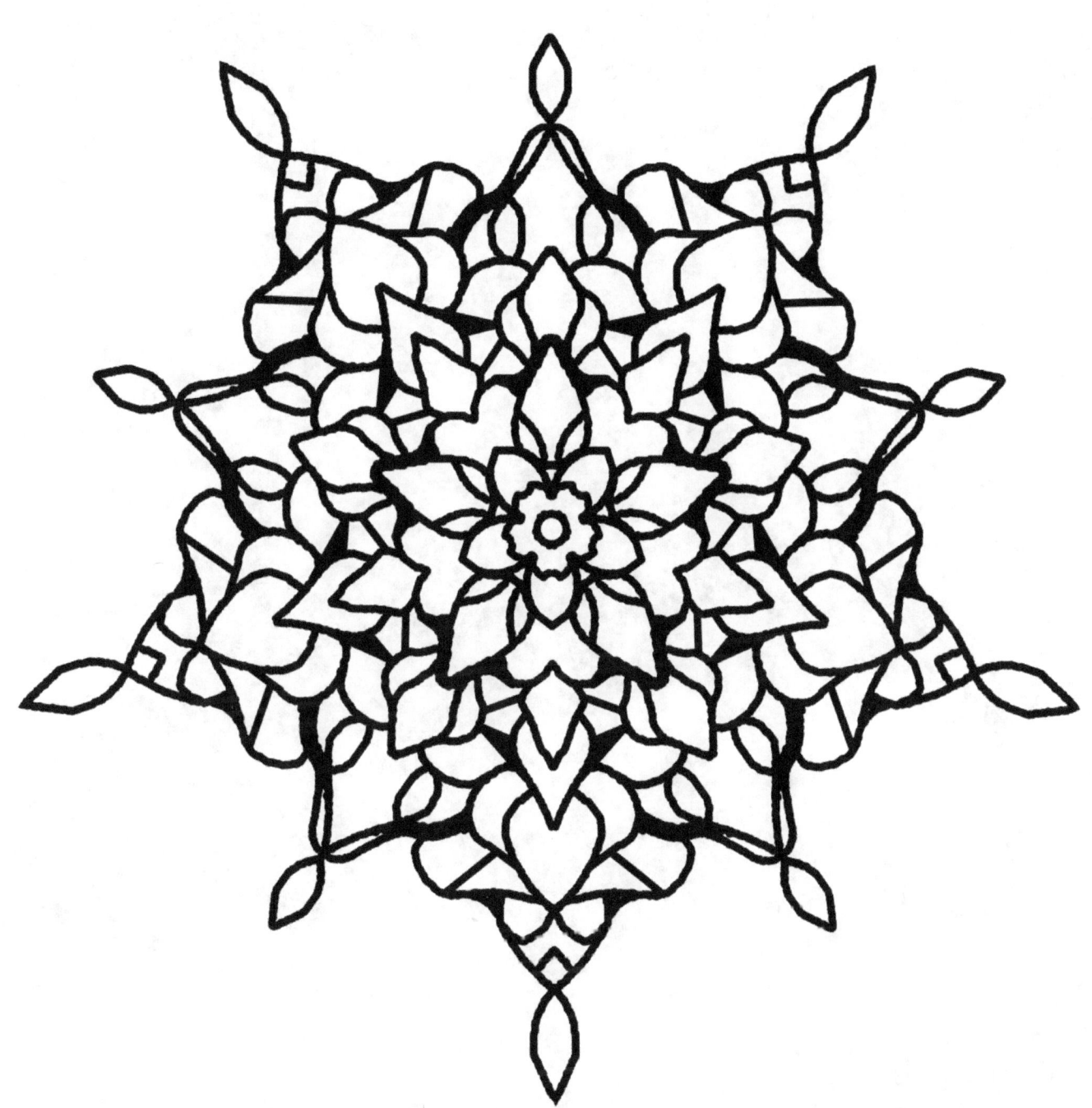

www.ingramcontent.com/pod-product-compliance
Lightning Source LLC
Chambersburg PA
CBHW081603220526
45468CB00010B/2755